IMAGES
of America

LONG ISLAND
ITALIANS

IMAGES
of America

LONG ISLAND
ITALIANS

Salvatore J. LaGumina

ARCADIA

First printed in 2000.

Published by Arcadia Publishing,
an imprint of Tempus Publishing, Inc.
2 Cumberland Street
Charleston, SC 29401

Printed in Great Britain.

Library of Congress Catalog Card Number: Applied for.

For all general information contact Arcadia Publishing at:
Telephone 843-853-2070
Fax 843-853-0044
E-Mail sales@arcadiapublishing.com

For customer service and orders:
Toll-Free 1-888-313-2665

Visit us on the internet at http://www.arcadiapublishing.com

CONTENTS

ACKNOWLEDGMENTS

Many individuals and organizations have been extremely cooperative in helping this publication come to fruition. I am especially grateful to the Piscitelli, Nuzzolo, Gorgone, Scarinci, Lanza families and to Frank J. Cavaioli, Nick LaBella, Jim Fiola, John Fiola, Joan Keefe, Leo Cimini, Roy and Joseph Tipa, John B. D'Elisa, Stella Cocchiola, Natalie Aurucci Steifel, Barbara Florio, Ann Carbuto, Thomas Moloney, Fr. Gerard Cestari, and the Long Island Catholic for the photographs provided. Likewise my thanks go to the Suffolk Historical Society, the Nassau County Reference Library, the Center for Migration Studies, the Order of the Sons of Italy, Dell 'Assunta Society, Our Lady of Mount Carmel Society, St. Anthony's Society, the Italian American Citizen Club, the Italian Genealogical Group of Long Island, the Long Island Chapter of the American Italian Historical Association, and the Italian Cultural Society of South Farmingdale.

For more information on Long Island Italians see my book, *From Steerage to Suburb: Long Island Italians*, in addition to a number of articles I have authored on aspects of this history.

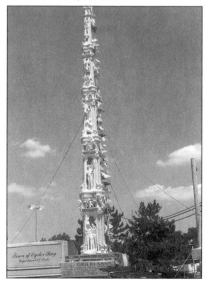

The Giglio Feast features a remarkable five-story structure with a statue of St. Paolino on top. Accompanied by Italian music played by a band perched on the lower part of the structure, the tower is lifted by more than 100 enthusiastic men.

INTRODUCTION

It was a combination of "push and pull" circumstances that caused millions of Italians to leave the land of their birth for a new country. Socioeconomic forces at work in Italy by the late 19th century saw that country struggling with a high birth rate, a poor educational system, and serious economic problems traceable to a deleterious agricultural system, inadequate industrial development, and an insufficient political system. Simultaneously, the United States served as a magnet for newcomers, particularly because of exceptional work opportunities. In addition, America could satisfy the spirit of adventure and the chance to escape from the rigidity of a highly structured class society. Furthermore, they knew that they could always return to the old country.

By 1900, more than 6 million Italians left for other lands, most coming to the United States. Although some were northern Italians, the majority were southern Italians who experienced shock as they were confronted with a different and higher standard of living, a strange and difficult language, unfamiliar customs and laws, and an occasionally hostile society. They attempted to cope with their tribulations by settling in congested, less desirable neighborhoods in large cities, such as New York, that were soon dubbed Little Italies. A smaller but significant number did, however, seek their fortunes in the West, while others opted for the suburbs.

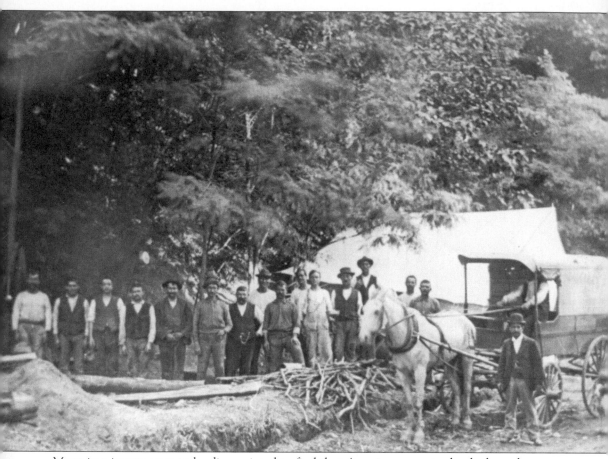

Many immigrants were to be disappointed to find that America was not a land where the streets were paved with gold. Indeed in many locales where there were no streets, Italian immigrants were the ones to build them, as shown in this photograph of Roslyn road workers.

One

Magnet Long Island

The South Shore

Suburbs were only beginning to emerge by 1900, with Long Island on it way to becoming the prototypical suburban model. The incorporation of Greater New York City in 1898, a major administrative change, affected Long Island in 1898 as Brooklyn and Queens, two counties physically on Long Island, became part of the nation's largest municipality. Consequently the Long Island appellation increasingly meant the counties of Nassau and Suffolk, to the east of the city. Into the first couple of decades of the 20th century, the two latter counties retained a bucolic atmosphere reflective of an agrarian past, with only a few industries to mar the rustic scene. Long Island—with its abundant beaches, lush, green pastures, commodious homes, marvelous landscapes, and serene pastures—remained an attraction for city residents who sought temporary escape from the rigors and stresses of big city living.

From the 1880s, the island also served as an allurement to a small number of Italians who began to establish ethnic enclaves in several communities by World War I (1914–1918). In the immediate post–World War II years, Long Island emerged as the nation's archetypal suburb as it attracted hundreds of thousands; the largest single ethnic group was made up of Italian Americans. In this setting, Italian Americans could indulge in the dream of owning a home or having a plot of land where they could plant vegetables and be in contact with the earth. They could thereby satisfy their longing to transplant the way of life from the old country to the new.

One of the first places in Nassau County to attract a sizeable number of Italians was Inwood in the southwest corner, where an important Italian enclave had begun to emerge by 1900. Some Italians secured positions as laborers in nearby towns that were developing recreational facilities to serve the expanding New York City population. Other Italians earned a livelihood working on the estates of wealthy landowners. Although many of Inwood's immigrants were Sicilians, the majority was made up of Albanian Italians—that is, descendants of Albanians who had fled to Italy centuries before and who, in addition to bearing Italian names and speaking Italian, spoke an Albanian dialect as well. This distinctive background survives and is reflected in enduring Albanian Italian organizations.

By the 1920s, Italian immigrants began to move into other communities in the southeastern part of Nassau, such as Valley Stream. Accordingly, Italian mutual aid societies, social organizations, food stores, and feast celebrations flourished.

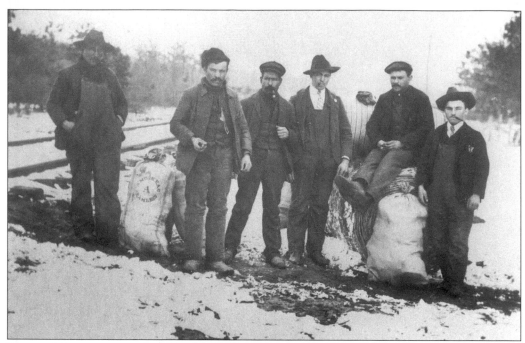

Foreign labor was critical to the development of transportation, America's greatest industry. Pictured are Italian workers who helped construct the lines of the Long Island Railroad (LIRR) into eastern Long Island.

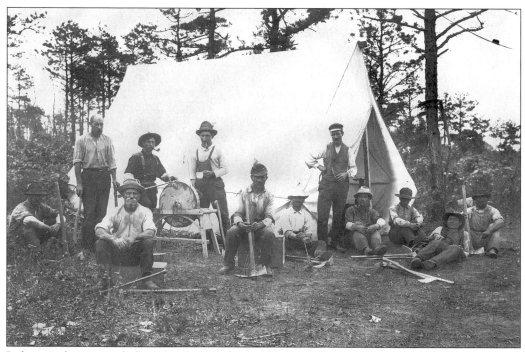

Italian work gangs toiled and lived on work sites, as revealed in this photograph. Arduous manual outdoor labor and primitive living conditions marked their lives in temporary tent homes.

Work on the Long Island Railroad was not reserved only for adults, as is shown by this photograph featuring a young Italian water boy.

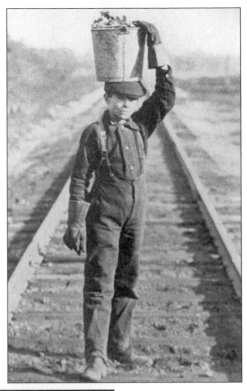

Working on the LIRR was a lifetime occupation for some Italian Americans, such as electrician Anthony Gorgone of Copiague. He worked with the railroad for 49 years. His Sicilian-born father and his son were also LIRR employees.

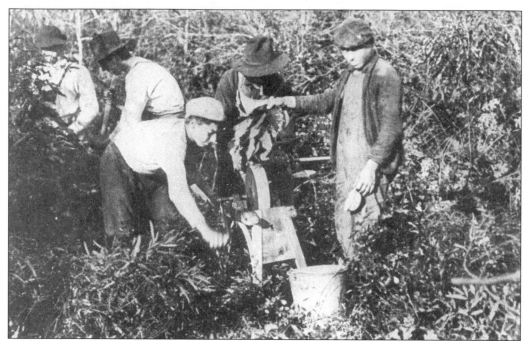

Although most Italian immigrants entered the work force as laborers in construction and mining, some used their experience of working the soil in Italy to good advantage on Long Island. Early in the 20th century, they became the mainstay of farm workers for the Long Island Railroad farm enterprises.

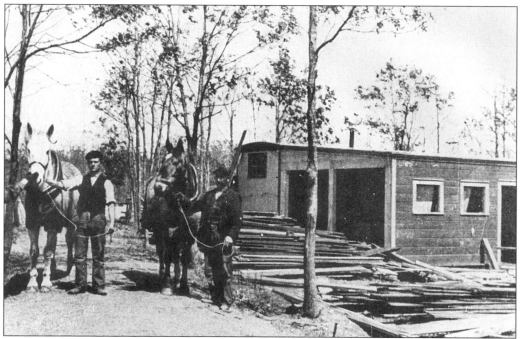

In an effort to encourage movement into eastern Long Island, the LIRR established experimental farms in Wading River and Medford. Although there were workers of different nationalities, the company relied increasingly on Italian farm labor.

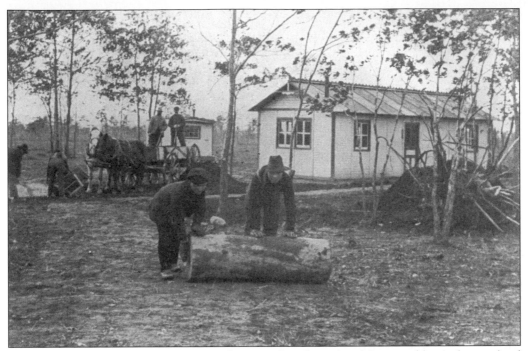

The ability of Italian farmers to transform scrub oak to fruitful, vegetable-producing land rendered them indispensable on Long Island. Italian immigrant labor transformed seemingly worthless scrub oak land in eastern Long Island into a productive farm enterprise capable of extraordinary results.

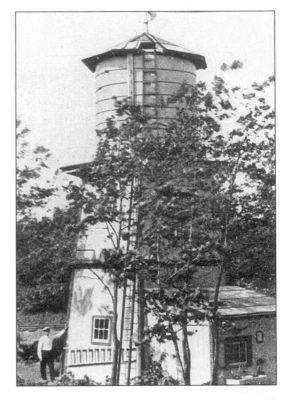

This picture shows a tower on the Wading River experimental farm, where a number of Italian workers worked and lived.

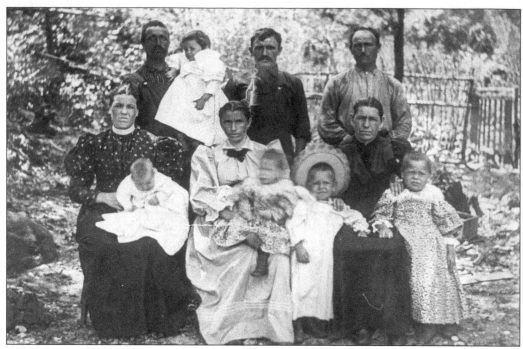

In locales such as Roslyn, pictured here, whole families accompanied Italian road builders.

Hailed as one of the finest roads of its time, the Vanderbilt Motor Parkway was constructed mostly by Italian labor.

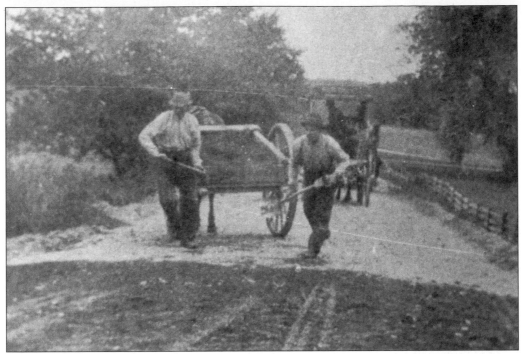

This photograph shows Italian road workers filling, backing, and leveling roadbed before paving.

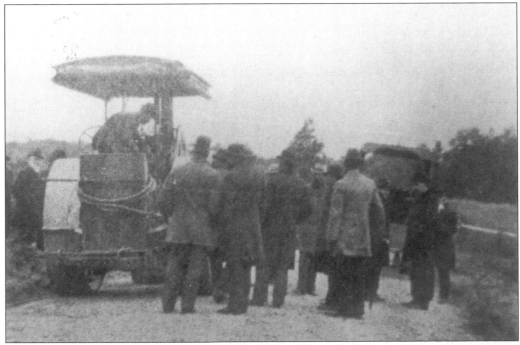

In this photograph, Italian workers look at a mechanical road-building equipment. In reality, it was primarily manual power rather than mechanical power that constructed Long Island roads in the early 20th century.

Fresh off the boat, Italian immigrants, such as this man, found employment on Long Island in labor-intensive occupations.

The end of the Spanish American War (1898) brought Italian immigrant George A. Minetty (third from left) to Long Island. Trained as a soldier in Italy, he fought with Theodore Roosevelt's "Rough Riders" and spent some time in Montauk Point, where the army established a camp for sick and convalescing soldiers. Minetty wrote a remarkable account of his life in the war and the sufferings that took place at Montauk Point.

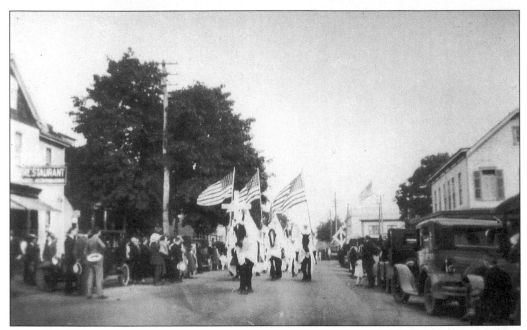

That Italian immigrants were one of the targets of the Ku Klux Klan is grossly apparent in the remarks of one of its leaders addressing a large Long Island audience in the 1920s, in which he decried a "dago pope." This photograph of Ku Klux Klan marchers verifies their activity in many Long Island towns.

Although Italian Americans became the largest single ethnic group on Long Island, they were not always welcome. This real estate broadside proclaiming "Italians Excluded" is blunt in assuring prospective home buyers that they would not be contaminated by the undesirable element.

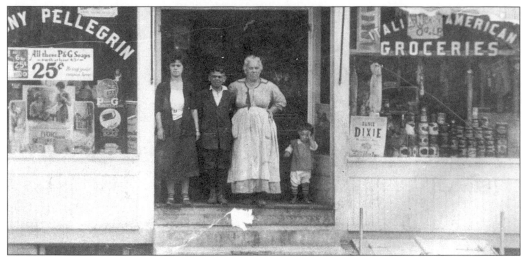

Pellegrino's Italian American grocery store was typical of such enterprises that abounded in Italian enclaves in suburban Long Island. Mothers, fathers, and children all worked to render the business a success by supplying familiar food products as well as granting fellow Italians credit.

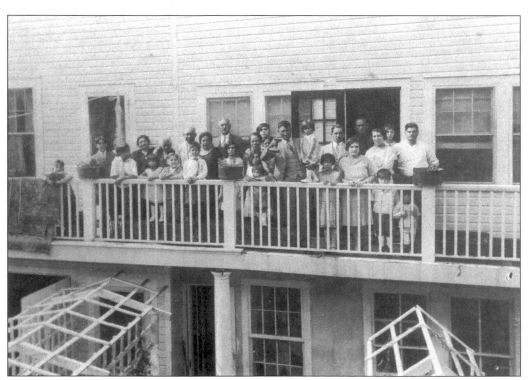

The Pellegrino backyard was the scene of numerous family gatherings in Inwood.

Family life was of major importance to Italian Americans. The Pellegrino family in this photograph shows the first and third generations of the family.

The Smeriglio Italian bank had an ethnic appeal to Inwood Italian Americans.

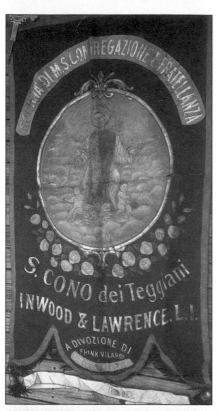

Pictured is the banner of the San Cono Society, formed in Inwood and Lawrence in 1907. This society was instituted by immigrants who venerated St. Cono dei Taggiani in Italy.

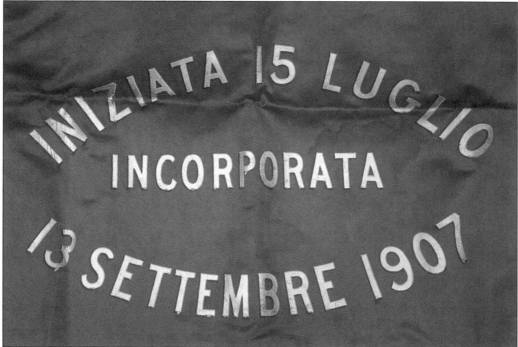

Another banner proclaims the inauguration of the San Cono Society. San Cono was regarded as patron saint of various small towns in Italy's Salerno region.

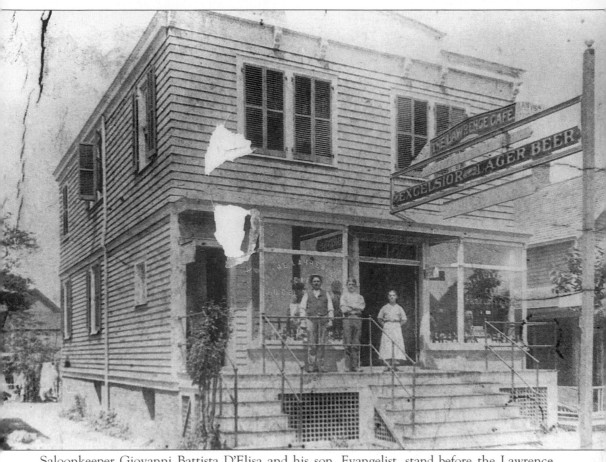

Saloonkeeper Giovanni Battista D'Elisa and his son, Evangelist, stand before the Lawrence Café in 1905. D'Elisa was one of the more prosperous immigrants in early Inwood.

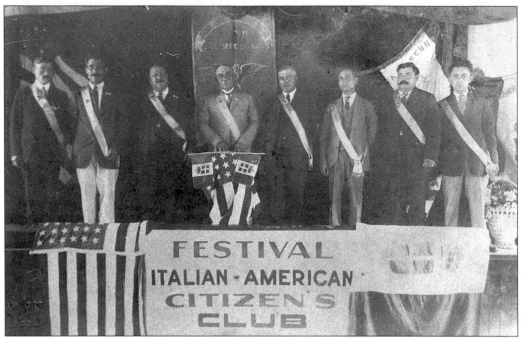

The actions of the Italian American Citizen's Club in the 1920s attests to the acceptance of civic responsibility on the part of Inwood's Italian Americans.

Inwood's Italian American Citizen's Club sponsored important functions of much interest to the local Italian community. In this photograph from the 1930s is a large assemblage bedecked with banners and flanked by the American and Italian royal flags.

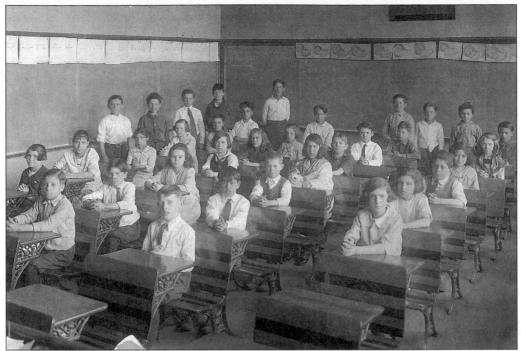

John and Nathan D'Elisa, second-generation Italian Americans, attended grade school No. 4 in Inwood *c.* 1922.

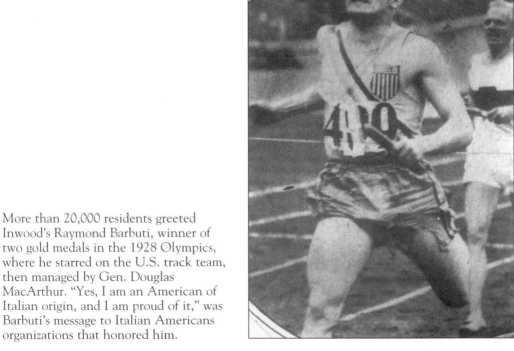

More than 20,000 residents greeted Inwood's Raymond Barbuti, winner of two gold medals in the 1928 Olympics, where he starred on the U.S. track team, then managed by Gen. Douglas MacArthur. "Yes, I am an American of Italian origin, and I am proud of it," was Barbuti's message to Italian Americans organizations that honored him.

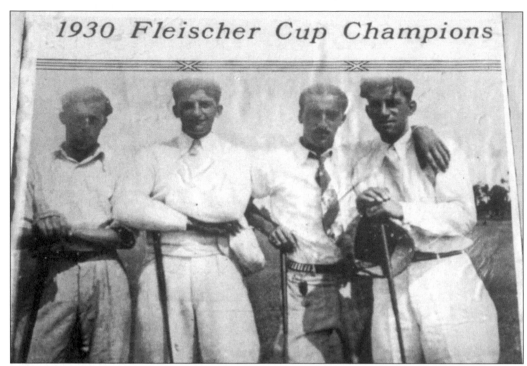

1930 Fleischer Cup Champions

Young Italian Americans from Inwood became familiar with the game of golf after serving as caddies for the affluent in nearby towns. In time they became so adept at the game that a number of them were able to play at championship caliber, as shown in this photograph. In 1946, a group of these Italian Americans purchased their own private golf course in Massapequa.

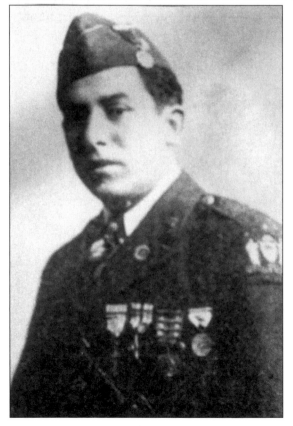

Many Italian immigrants served in the American armed forces during World War I. One was (Fiorentino) Ferdinand Nuzzolo, an Inwood barber who was awarded a medal belatedly for his bravery in saving the life of an American officer.

Corriere D'America, an Italian language newspaper, used banner headlines as it proudly hailed the heroism of Inwood's Ferdinand Nuzzolo in World War I.

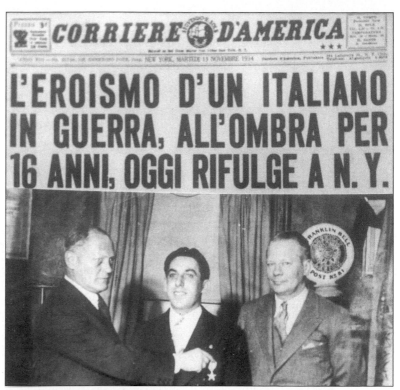

CORRIERE D'AMERICA

NEW YORK, MARTEDÌ 13 NOVEMBRE 1934

L'EROISMO D'UN ITALIANO IN GUERRA, ALL'OMBRA PER 16 ANNI, OGGI RIFULGE A N.Y.

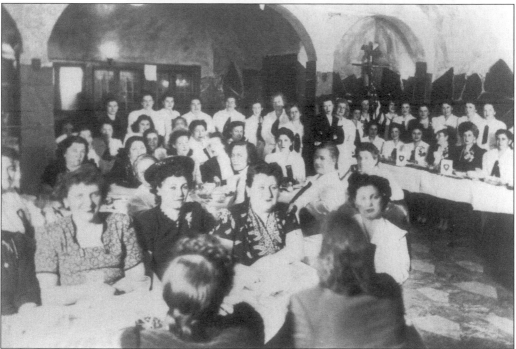

Inwood Italian Americans were also conspicuous in World War II. This 1947 photograph shows the Women's Auxiliary meeting of Oliveri Veterans of Foreign Wars Post. John Oliveri was the first soldier from Inwood to die in defense of the country.

The Zavatt family was one of the most prestigious in Inwood's Little Italy. Immigrant Vincent Zavatt, right, was deputy sheriff and a real estate entrepreneur. His son, Joseph, was one of the first Long Island Italian Americans to become a federal judge.

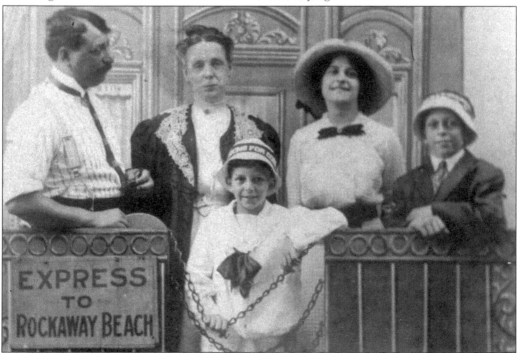

EXPRESS TO ROCKAWAY BEACH

Proximity to the Rockaways, which by the early 1900s was becoming a recreational outlet for New York City, attracted Inwood families, such as the Zavatts, shown here.

The St. Anthony of Padua Catholic Church of Oceanside featured a famed outdoor church, shrine, and garden that attracted thousands of people, especially Italians. News accounts reported that Italians walked on their knees before the shrine, as was their custom in Italy.

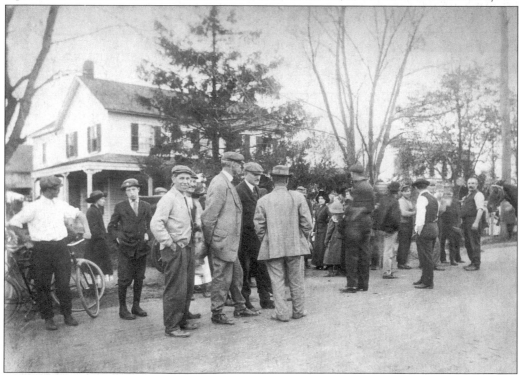

Michael and Joseph Vigotty (Vigotti) were probably the first Americans of Italian descent to settle in the Woodmere-Lawrence area. Michael possessed sizeable real estate, including the home visible in this picture, which shows several members of the Vigotty family and others gathered at the site of an accident.

GRAND ANNUAL BALL ✿✿✿ 462

—OF THE—

Societa Politica Italo Americana

AT DI SIMONE'S BROADWAY HALL,

98 Broadway, Long Island City,

On Thursday Evening, October 12th, 1899.

....OFFICERS....

CAPT. M. DISIMONE, PRES. PIETRO SPAZIANO, VICE-PRES. STEFANO DI GAETANO, TREA

RALPH DISIMONE, FIN. SEC. ANTONIO GIBERTI, SEC. G. VLANCACIK, SGT-AT-ARM

HON. A. ZUCCA, PATRON.

TICKETS, Admitting Gentleman and Ladies, 25 CENTS.

An early attempt at Italian American political participation and influence in Long Island is evident in this picture. It reveals the existence of ethnic political organization as early as 1899.

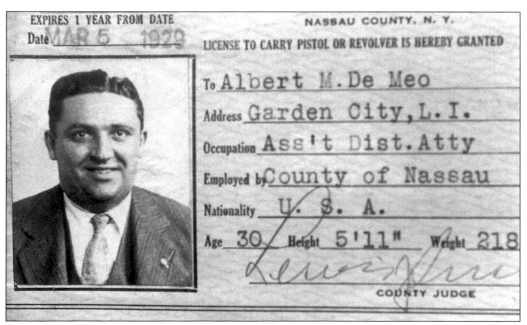

Albert DeMeo, of Port Washington's Italian enclave, was among the first of his nationality to become an assistant district attorney of Nassau County.

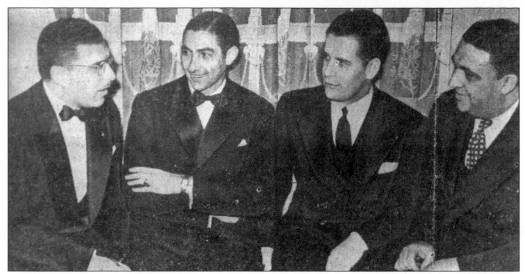

Frank Gulotta, of Sicilian ancestry, became the first Italian American elected to countywide office as district attorney. In this photograph, he is shown with other members of Italian American Republican Clubs in the 1930s. Pictured, from left to right, are F. Gulotta, two unidentified men, and Albert DeMeo.

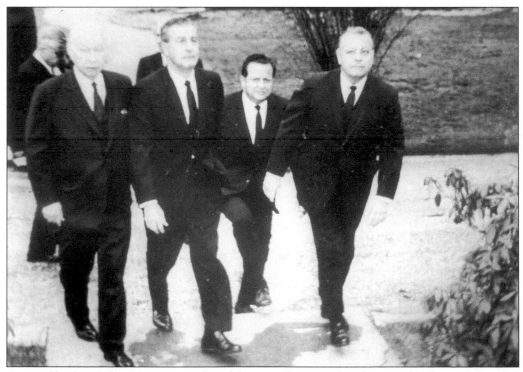

A trio of leading Italian American political figures is shown in this photograph. They are, from left to right, as follows: A. Holly Patterson, Nassau County executive; Joseph Carlino of Long Beach, New York State assembly speaker; Edward Speno of East Meadow, New York State assembly speaker; and Nassau Republican leader Joseph Margiotta of Uniondale, assemblyman.

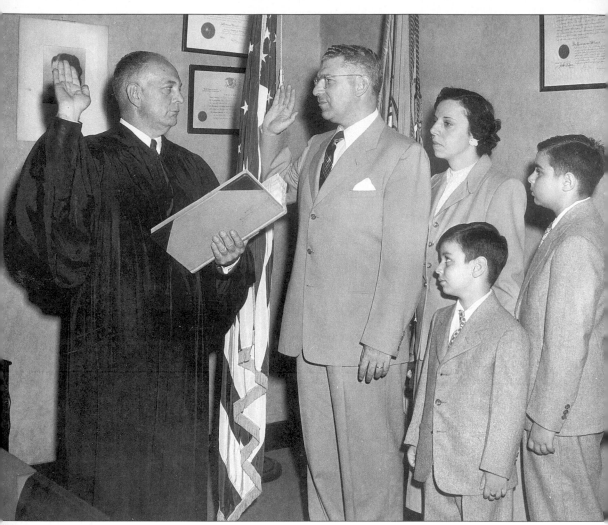

Of Sicilian ancestry, Frank Gulotta is sworn in as Nassau County district attorney in 1952. Gulotta, the first of his nationality elected to a countywide position, became a respected New York State Supreme Court judge. His son, Thomas, became county executive.

Two

Nassau

The North Shore

The fabled "gold coast" of the north shore that was the setting for one of the country's major concentrations of mansions for the wealthy, Nassau's north shore was also an attraction for Italian immigrants, albeit of a proletarian social class. In search of work, they found their way to such towns as Oyster Bay, Port Washington, and Glen Cove. As cheap labor, immigrants from Avellino were indispensable for the successful operation of Port Washington's productive sand mines; they performed the dangerous work of unearthing and shipping the valuable natural resource. Becoming the nucleus of ethnic enclave, they played increasingly important roles in Port Washington's political, social, economic, educational, and civic life, electing school board members, producing an Italian language column in the local weekly newspaper, and sponsoring numerous Italian events. By 1911, sufficient Italian Americans lived in Oyster Bay to organize ethnic societies.

Simultaneously, an important concentration of Italian Americans had sprung in the city of Glen Cove, where once again economic factors loomed large. That municipality housed a major sugar refining company, small factories, a construction site, and opulent estates that required considerable workers. Southern Italians, especially from Sturno, immigrated to Glen Cove, where within a generation they had emerged as important participants not only within that city, but also beyond, becoming particularly prominent in politics. Glen Cove boasts of the oldest Sons of Italy lodge in the county and the Church of St. Rocco, the only Italian national parish on Long Island—the ethnic orientation of which is manifested in feast celebrations, Italian language Masses, and weddings.

Possessing some of the finest sand for construction needs, Port Washington sand mines attracted hundreds of Italians to perform the dangerous work of unearthing and sifting the sand in deep pits. Deep excavations are amply demonstrated in the photograph above.

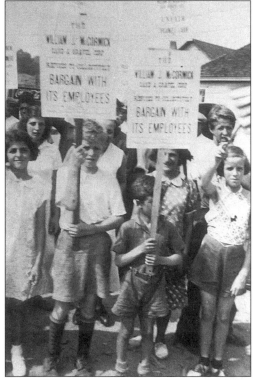

Left: Unwilling to work indefinitely for low wages and long hours, Italian Americans were among the first to strike for improvements. As this photograph demonstrates, they were ready to strike in behalf of their demands. *Right:* This photograph shows children of miners joining their parents in striking in an impressive illustration of solidarity.

This photograph of a work scene in the sandpits provides some idea of the conditions in which Italian sand miners worked. The work was arduous and dangerous, and more than a few local families suffered major casualties.

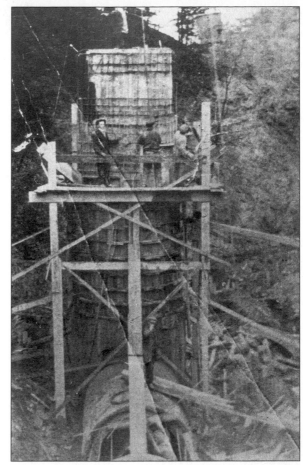

As the largest ethnic element among sand miners, Italian Americans such as Al Marino, pictured below, were for years active in organizing the workers. Efforts to improve wages frequently succeeded.

Santo Bassi spent most of his productive years working in Port Washington's sandpit.

In the late 19th and early 20th centuries, immigrants from Avellino boarded in the home of James Marino, a *padrone* (labor boss) and mine operator. During slow seasons, Marino had his men construct this imposing structure, which displays the artistic skill of Italian stone masons. The Marino home has been demolished in order to accommodate a supermarket parking lot.

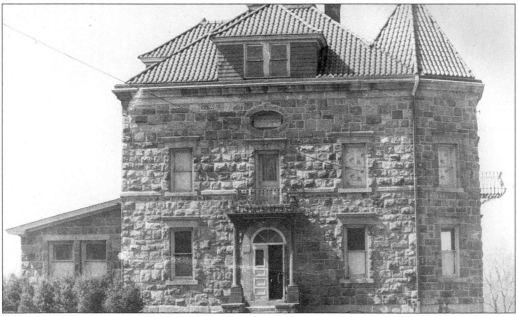

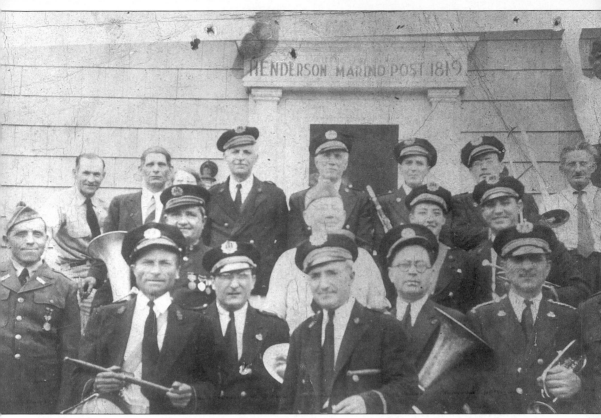

This Italian American band poses in front of the Henderson-Marino Veterans of Foreign Wars Post, in part named after a son of an Italian pioneer to Port Washington. The son was an American soldier who was a casualty in World War I.

Proud of his army service in World War I, Port Washington's Nicholas Sica participated in military parades for years. An arrow in this photograph shows him with an army contingent.

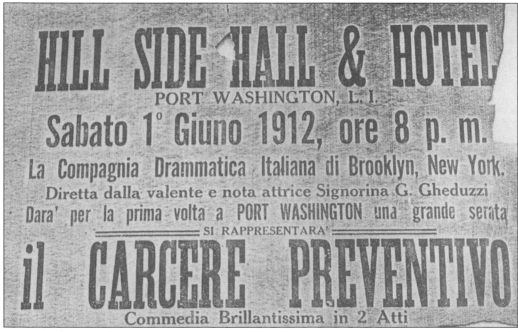

HILL SIDE HALL & HOTEL
PORT WASHINGTON, L. I.
Sabato 1° Giuno 1912, ore 8 p. m.
La Compagnia Drammatica Italiana di Brooklyn, New York.
Diretta dalla valente e nota attrice Signorina G. Gheduzzi
Dara' per la prima volta a PORT WASHINGTON una grande serata
═══ SI RAPPRESENTARA' ═══
il CARCERE PREVENTIVO
Commedia Brillantissima in 2 Atti

Recently uncovered, this photograph of a 1912 Italian ethnic theater announcement reveals the existence of a substantial Italian American population in Port Washington to warrant the melodramatic performance.

Although there were Catholic parishes in Glen Cove, Italian Americans in the 1930s petitioned and built their own—St. Rocco. It remains the only ongoing Italian national parish on Long Island.

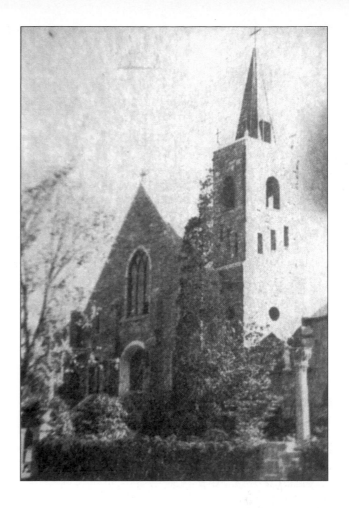

Molti migliaia di Italiani residenti nella citta di Glen Cove e Vill.... circonvicini non hanno mai pensato che essi sono proprio della stirpe ... Religione Cattolica ed Apostolica Romana. Percio oggi e'venuto momento di doversi riunire tutti e darsi a conoscere di essere veri Ita....

Essi qui sottoscritti vogliono la Chiesa Italiana col nome di San Rocco, e col prete Italiano.

Nome Indirizzo Citta o Villaggio

This petition circulated by Glen Cove Italian Americans tells of thousands of their background requesting a Catholic church of their own as well as an Italian priest. In 1936, this petition was presented to Cardinal Eugenio Pacelli (future Pope Pius XII) while he was on a visit to a nearby Long Island town.

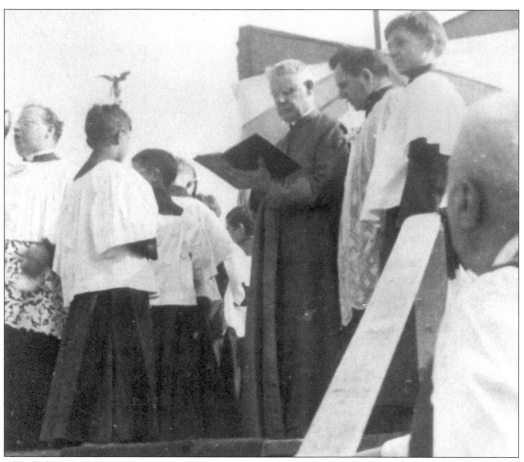

The dedication day ceremony for Glen Cove's Church of St. Rocco was photographed in 1937.

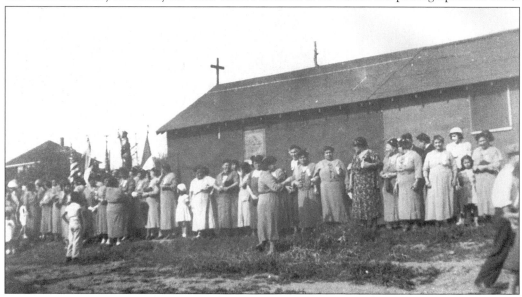

Women of St. Rocco assemble at the groundbreaking for St. Rocco's Church in 1937.

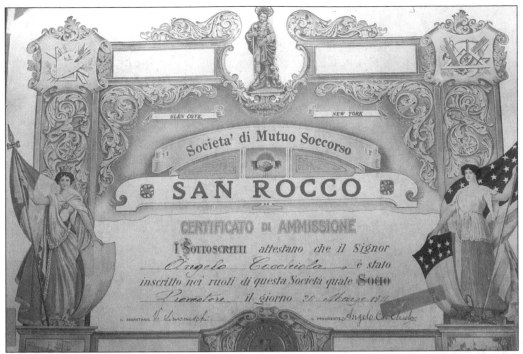

The creation of the San Rocco Mutual Aid Society of Glen Cove in 1911 is illustrated in this decorative scroll. Its first president, Angelo Cocchiola, was considered the unofficial mayor of the town's Little Italy.

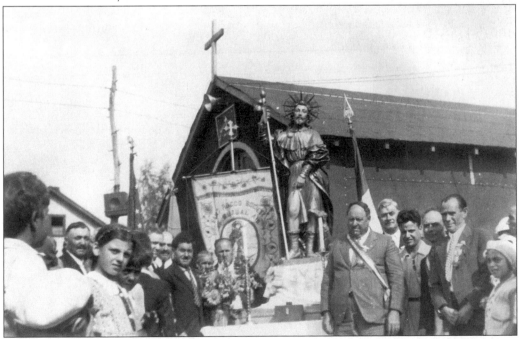

It was a happy occasion for Pres. Angelo Cocchiola of the San Rocco Society and its members to be present on the dedication day of Glen Cove's Church of St. Rocco. The church was built on land obtained by the San Rocco Mutual Aid Society.

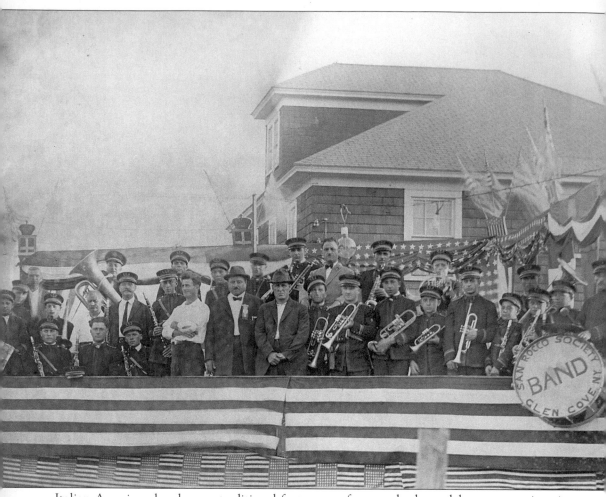

Italian American bands were traditional features on feasts and other celebratory occasions in Italian American communities. Shown is one such band, which played during the St. Rocco groundbreaking ceremonies.

Mr. _____

Care of ANGELO COCCHIOLA

BIGLIETTI DI PASSAGGIO DA E PER L'ITALIA

con le migliori Compagnie di Navigazione.

CURA LA SPEDIZIONE DI MONETA

per tutti i Paesi e Villaggi d'Italia.

:·: **NOTAIO PUBBLICO** :·:

Box 448. **GLEN COVE, L. I., N. Y.**

S. U. of A.

Box 448 was the first address for many Italian immigrants to Glen Cove. It was the home of Angelo Cocchiola, who was a notary public and provided transportation and banking services for fellow Italians.

The original Cocchiola house has been home to family members from the early 20th century into the 21st century.

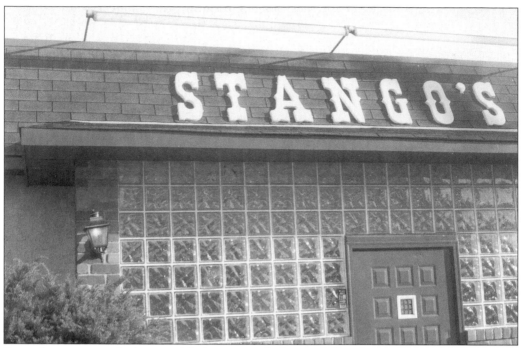

Stango's restaurant, which opened for business in the heart of Glen Cove's Little Italy in 1919, still pleases customers with the type of food that made it popular among immigrants if an earlier era.

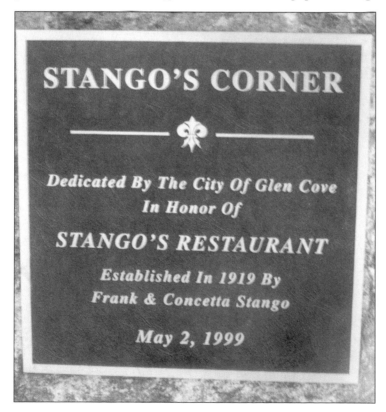

STANGO'S CORNER

Dedicated By The City Of Glen Cove In Honor Of

STANGO'S RESTAURANT

Established In 1919 By Frank & Concetta Stango

May 2, 1999

Operating continuously for 81 years, Stango's can probably lay claim to Italian American restaurant longevity on Long Island. On this plaque, the City of Glen Cove acknowledges "Stango's Corner."

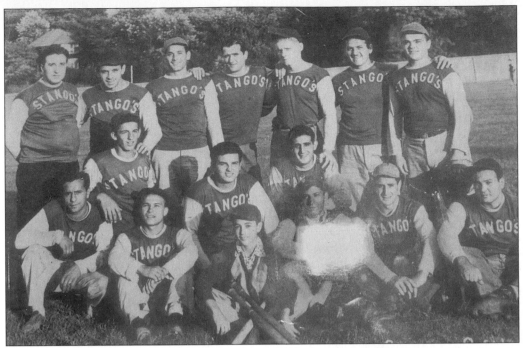

This sports team was sponsored by Stango's, c. 1940. Activity of this type was important in building up a spirit of pride within the ethnic community.

Lieutenant J. Fusco, from a pioneer Italian family in Glen Cove, was one of many of his background to serve in the U.S. Army during World War I.

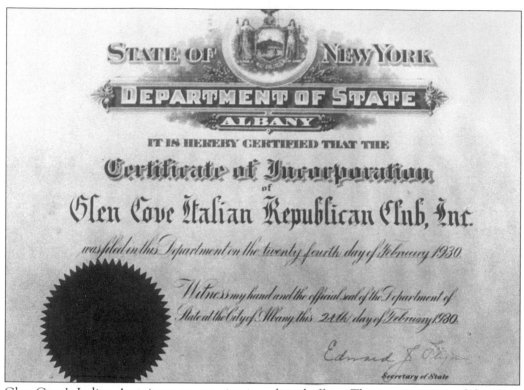

Glen Cove's Italian Americans were active in political affairs. The incorporation of the Glen Cove Italian Republican Club in 1930 firmly attests to this.

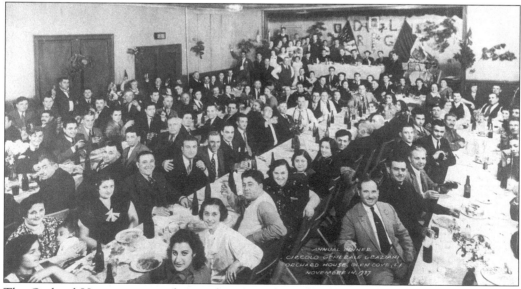

The Orchard House was a settlement house vital to Glen Cove's Italian Americans. Among other services, it provided halls where Italian Americans held functions, such as this dinner of the Circolo Generale Graziani in 1937.

Sister Thomas directs the young Italian American women in Glen Cove's Orchard House who boosted morale of soldiers by writing letters during World War II.

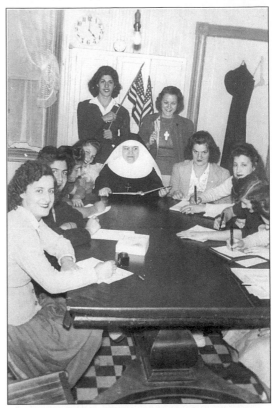

Aware of their ancestry, Glen Cove's Italian Americans were even prouder of their American nationality and willingly served in the armed forces. Fighting in the Pacific theater prompted battle-hardened U.S. Marine Sgt. Alfred Carbuto to write the march tune "Get Your Gear on, We're Moving out Again," a song that became a special feature on popular radio programs. In this photograph, Carbuto (center) poses with his family.

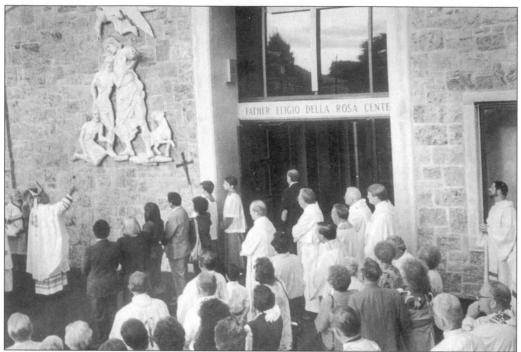

In this 1992 photograph, Glen Cove Italian Americans gather at St. Rocco's Church at the dedication of a hall named after popular pastor, Fr. Della Rosa.

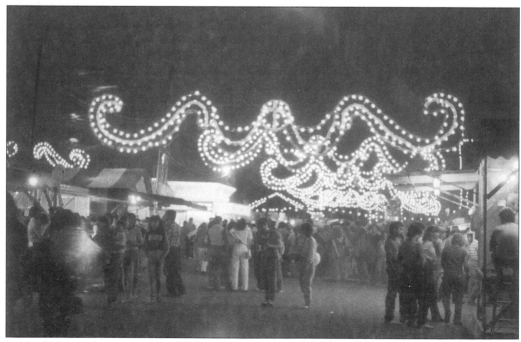

Bright lights outline crowds at St. Rocco's Feast in Glen Cove, 1983.

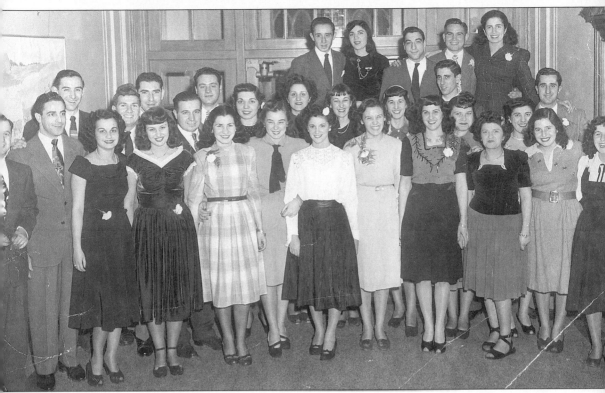

Young Italian Americans socialize during a dance in the Orchard House in the 1950s. Vincent Suozzi, future mayor of the city, is third from left.

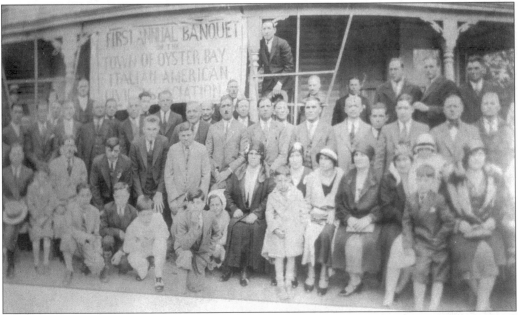

The members of the Italian American Citizen Club of Oyster Bay formed their ethnic fraternal society early in the 20th century. This photograph shows members and families proudly surrounding their banner on the occasion of their first banquet.

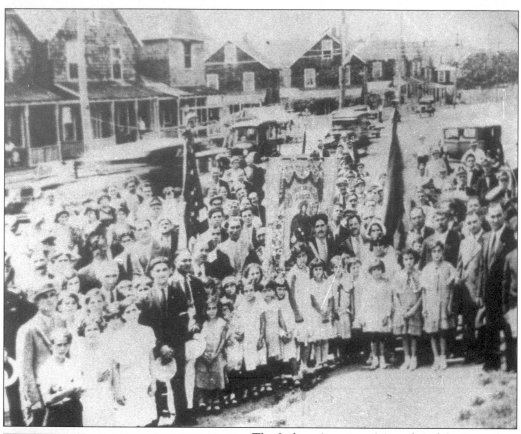

The Italian American Mutual Aid Society of Oyster Bay, formed in 1910, attracted large numbers of people on the occasion of the celebration of St. Rocco's Feast in 1931.

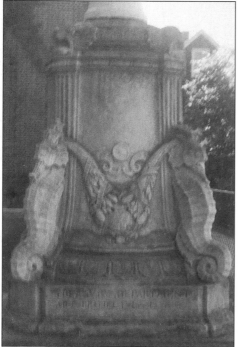

In the bitter winter of 1936–1937, the U. S. Treasury Department paid immigrant Leo Lentelle $2 a day to carve this granite sculpture as the base for a flagpole in front of the Oyster Bay Post Office. It features four large seahorses and is an extraordinary and enduring example of the Italian creative talent that has beautified the area.

For decades, the Italian American Citizen Club of Oyster Bay has had its own clubhouse for meetings and events.

The bocce courts of the Italian American Citizen Club of Oyster Bay are the sites of serious tournaments as members play the game inherited from their ancestors.

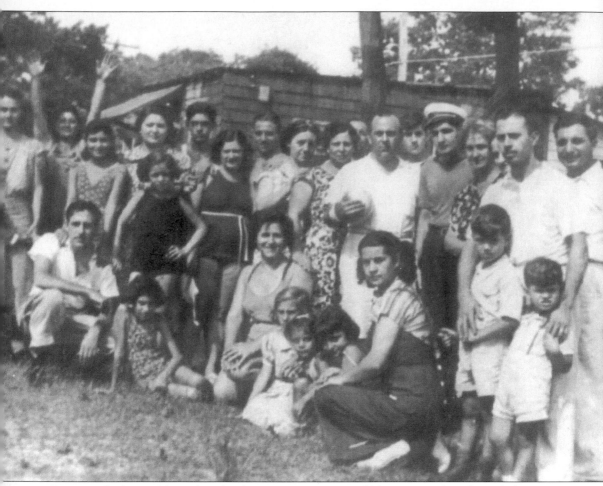

Enjoying the beautiful, verdant landscape in numerous parklike settings that abounded on Long Island, many New York City Italian Americans were introduced to the area in the pre–World War II era. For the Marzano family of Brooklyn, summer Sundays in 1939 meant roasted chickens, macaroni, and wine at picnics in Bayville.

Three

CENTRAL NASSAU COUNTY

Italian immigrants began to establish small colonies in central Nassau County by the early 1900s in towns such as Mineola, Farmingdale, Elmont, Franklin Square, and Westbury. In these places they found work as laborers—for example, in Farmingdale, where they were employed in brick making. In time, they formed mutual aid societies, including Our Lady of Mount Carmel in Franklin Square and the Italian American Association of Elmont.

Italians had a primary impact in Westbury, where they were the mainstay laborers in major nursery businesses and staffs for numerous large estates encompassing hundreds of acres. Within a generation, there were signs of upward mobility—for instance, Constantino Poscillico, a laborer whose industry, frugality, and wise real estate investments eventually enabled him to purchase the estate on which he previously worked. He proceeded to subdivide the estate to build homes for his ten children.

Coming largely from Nola, Saviano, and especially from Durazzano, near Naples, Westbury Italian Americans were destined to become critical in the life of the community. They formed associations such as the Durazzano Society, wherein membership is restricted to those born or connected to Durazzano. The Dell' Assunta Society, another Westbury organization, boasts that it has celebrated the Dell' Assunta Feast continuously since its founding in 1911, even during the ominous years of World War II. Ties to Durazzano remain so close that in the 1990s Westbury and Durazzano formally formed a sister relationship.

Founded in 1941, the St. Anthony's Benevolent Society is firmly entrenched in Elmont. Built in 1971 in the heart of Elmont's Italian area, the clubhouse of St. Anthony's Society on Meacham Avenue houses a religious chapel where bread is blessed on the occasion of the June celebration of St. Anthony of Padua.

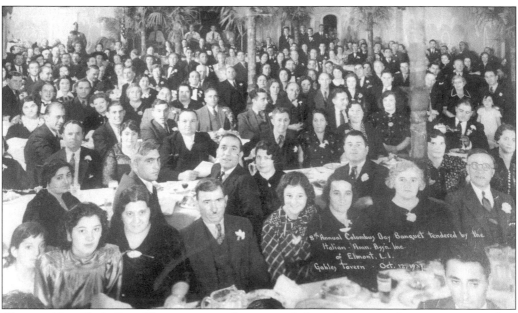

Close to New York City, Elmont attracted so many Italian Americans that at one point they comprised over 41 percent of its population. The Italian American Association of Elmont drew hundreds of them to its annual Columbus Day banquet. This photograph shows the 1937 banquet.

The growing Italian American population of Franklin Square found a need to form Our Lady of Mount Carmel Mutual Aid Society in 1936. In the 1950s, as in the decades before and after, society members took special pains to dress on the occasion of the feast day celebration of their saint.

Combining a fraternal with religious heritage, the association has sponsored a July Feast of Our Lady of Mount Carmel. In this photograph, members are shown before the statue of Our Lady of Mount Carmel housed in their own chapel in Franklin Square.

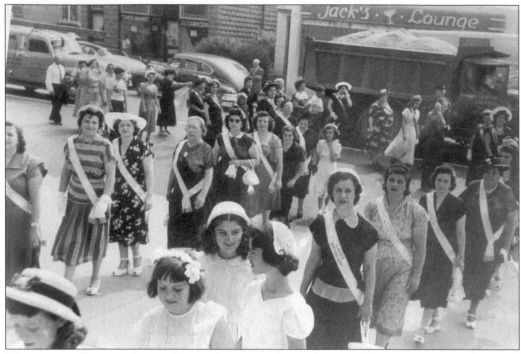

Women proudly wear their sashes, and young girls in white march in procession in honor of Our Lady of Mount Carmel in Franklin Square in the 1950s.

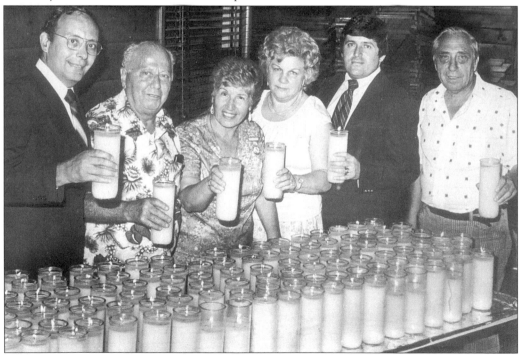

Hempstead supervisor and future U.S. senator Alphonse D'Amato joins members of Franklin Square's Our Lady of Mount Carmel Society in lighting candles on the occasion of celebrating the Feast of the Blessed Mother.

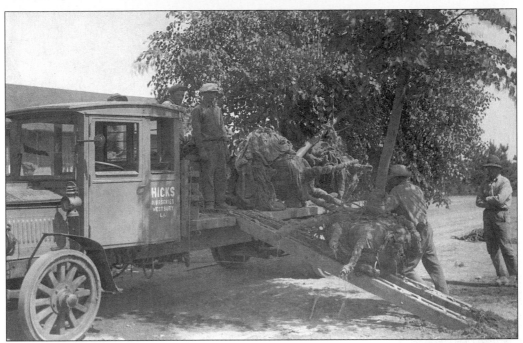

A large number of Italian immigrants in Westbury worked for the Hicks Nursery, then one of the most respected businesses of its type on the East Coast. This picture is indicative of the kinds of activity performed.

From Durazzano to Westbury was the itinerary that numerous Italian immigrants took early in the 20th century. Many of them worked in large nurseries or estates of affluent Long Islanders.

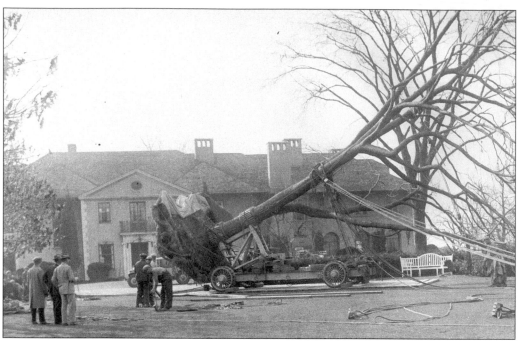

Hicks Nursery was responsible for major garden and nursery projects that extended far beyond Long Island. Thus local Italian Americans were sometimes employed in projects as far south as Virginia to transplant large trees, as portrayed in this picture.

Wages received here by average Italian. Sept.'05 -Sept.'06			
Marcus Daddio.	Hrs. per wk.	Storms.	Absent while men
1905. Sept.	54-68-63-64	No outside Work.	same grade worked
Oct.	66-57-53-64	1 rain	outside.
Nov.	65-63-61-61-50	1 rain	
Dec.	59-64-44-40	1 rain	1 absent
1906. Jan.	52-56-40-61	1 storm	1 absent
Feb.	43-50-57-31	2 storm	2 "
Mar.	60-40-35-49	2 storm	2 "
Apr.	63-45-63-57		
May	65-60-54-63		2 "
June	47-67-60-55-62	1 storm	
July	52-53-43-63		3 "
Aug.	54-63-63		
12 mo.	2721 hrs	@ 15 = $408	
Storms, 9 da.@1 50		13 50	
Absent days, 11 day		16 50	
		$438 00 Year.	

Another Hicks Labor Ledger record of 1912 graphically illustrates the typical weekly wage of $9 and an average annual salary of $430. Also note the frequency of layoffs.

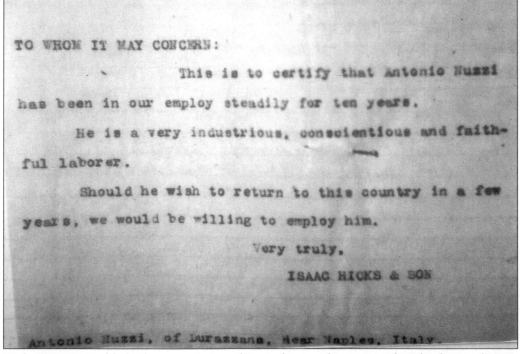

Ross, Joe								A
ESS								B
								C
								D
FIRST EMPLOYED			TIME KEY NO.			DEPT.		E
NALITY Italian.			U. S. CITIZEN?			MARRIED? Yes		F
			RATE OF WAGES (10 HOUR BASIS)			CHILDREN? Yes		G
								H
DATA Aug '06 Nov Nov.			DATE QUIT Aug. '06		CAUSE Not wanted.			I
RATE had 15 16 17½			DISCHARGED					J
								K
RD Small.								L

Striker, very active, leader. Left that week returning overpay
V.W. "Could teach men to be lazy. Frequently tells men to 'take
"it easy' (sounds like "Johnny John") Dont want him around"
Taken on Nov.6,'06, went to Rhinebeck,
Left Jan.26, Paid off Feb.2.

Hicks Nursery kept careful records of its workers, the overwhelming majority of which were from Durazzano. This image provides valuable information on a Joe Ross who was considered the leader of a 1906 strike. Notice that although the nationality is Italian, the name was Anglicized, something that occurred rather frequently.

TO WHOM IT MAY CONCERN:

This is to certify that Antonio Nuzzi has been in our employ steadily for ten years.

He is a very industrious, conscientious and faithful laborer.

Should he wish to return to this country in a few years, we would be willing to employ him.

Very truly,

ISAAC HICKS & SON

Antonio Nuzzi, of Durazzano, near Naples, Italy.

Hicks Nursery could also be appreciative of its workers, as demonstrated in this letter of 1914.

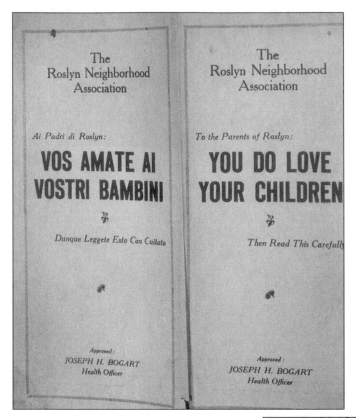

By 1916, the Italian population in the north central part of Nassau had reached such numbers that the Roslyn Neighborhood Association found it necessary to print warnings in Italian cautioning them to take health precautions against a devastating epidemic of infantile paralysis.

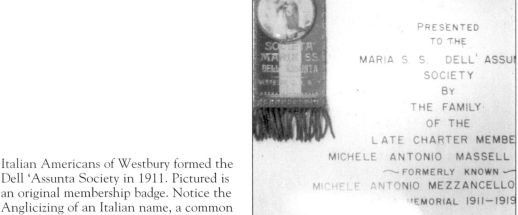

Italian Americans of Westbury formed the Dell 'Assunta Society in 1911. Pictured is an original membership badge. Notice the Anglicizing of an Italian name, a common practice at the time.

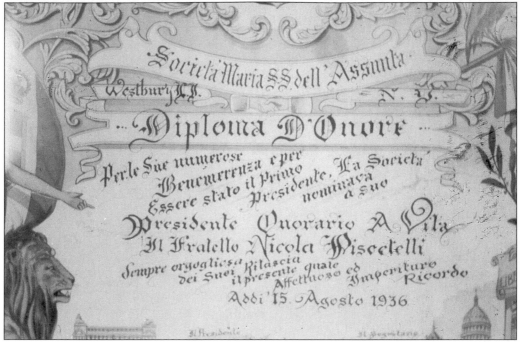

In 1936, the Dell 'Assunta Society presented a fancy scroll to Nicola Piscitelli, the society's first president.

Like his father, Dominick Piscitelli also became president of the Dell 'Assunta Society. He became Westbury village's first Italian American mayor in 1974.

Joseph Piscitelli, cousin of Dominick, became president of the Dell 'Assunta Society in the 1980s.

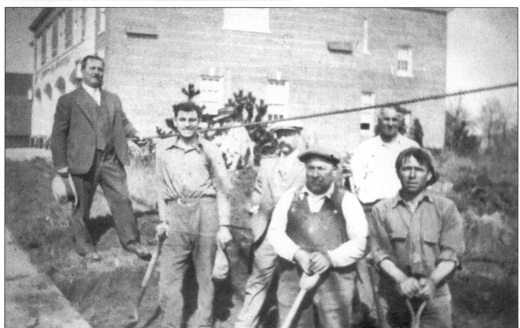

This photograph shows members at work in construction of the Dell 'Assunta Society hall that became the focal point for meetings, dances, and innumerable wedding celebrations. Both society and the Dell 'Assunta hall endure.

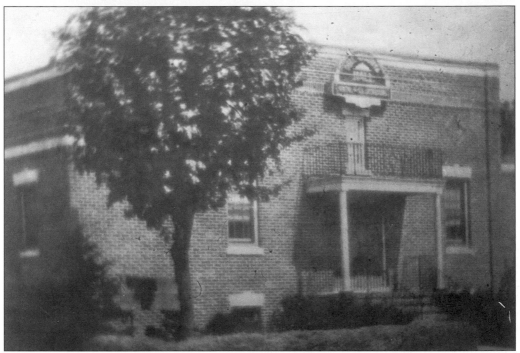

Members of the Dell 'Assunta Society were proud of their newly constructed hall on Maple Street in Westbury. For years, it served as the site of numerous organizational and private parties.

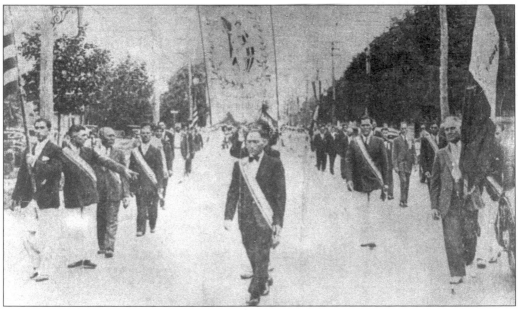

In its heyday, Dell 'Assunta Feast celebrations attracted tens of thousands. Large processions were highlights, as this picture shows.

A' FESTA D' ASSUNTA O' WESTBURY

CANZONETTA D' OCCASIONE

Versi di B. SIANO

Musica di J. SIMONETT

1.

Iurnate Fatt'apposta Pe' sta festa
Turnate ogn'anno e quinnic'e stu mese
Purtata a' gioia a tutto stu paese
C'a nanno sano st' aspettanno gia'
P'a Mamm' ASSUNTA regina do cielo
Fa festa tutt'o munno e tale e quale
Se po chiamma' na festa mondiale
E sta iurnata l'amma rispetta'

Cu sti luce e sti bellizzi
Cca' me pare m miezzurno
Chest' agente pe cc'attuorno
So venute pe senti'
Chesta musica che sona
Piezzi d'opera e canzone
Vo vede' che fa girone
Mo ca o' fuoco adda spara'

2.

E furrastieri corron'a micliara
A tutte e parte pe vede' sta festa
E dicen' alluccanno meglie e chesta
O comitato n'a poteva fa'
Chist'anno pur'e femmene hanno fatto
A parte lloro comm' anno potuto
E quanno camminavano mparata
Ncantat' acente hanno fatto resta'

Sta Societa' e Femmene
So nu ciardin' e rose
Sultanto stu paese
Tene sta gioventu'
A' Presidentessa Foglia
Si dice na Parulella
N'acen'e muscarella
Te pare e tammucca'

3.

Facenn'o cunto cca' tutte'e preciso
Ninte nce manca sena bada' spese
A festa che facimmo a stu paese
A mamm'e tutte e feste a pud' chiamma'
Sta Societa' ogn' annd fa furore
Ste musiche so tutti professuri
Chesta lummata e bell' addirittura
Niente chiu' meclio se poteva fa'

Sta musiche e' nu zucchero
Quacliv' vattite e mane
Da mo fin'a dimae
Cantate apreiso a me

EVVIVA O COMITATO
EVVIVA O PRESIDENTE
EVVIVA, DELL' ASSUNTA
CHE, FA, STE, NOVITA'!

The Dell 'Assunta Feast inspired local Italian American songwriter B. Siano to compose a melody in Italian.

Formal social functions, such as this one in the 1940s, were regularly held in Dell 'Assunta hall before World War II.

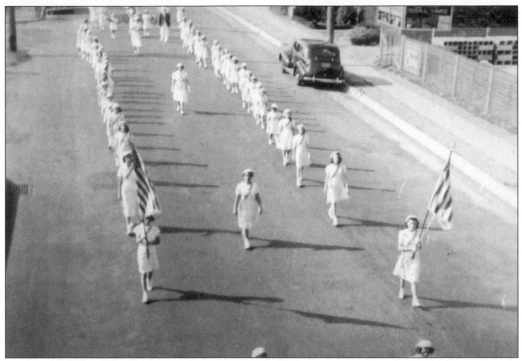

Young members of the Dell 'Assunta Society march down Post Avenue, Westbury's main street.

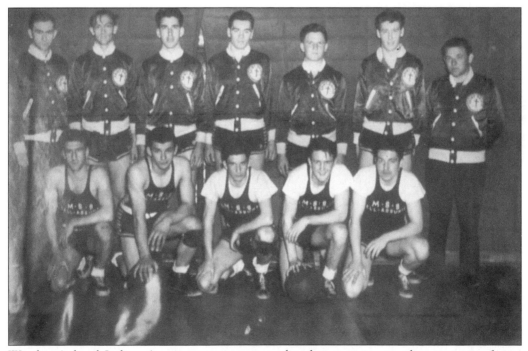

Westbury's local Italian American organization played its part in providing activities for its youth. The basketball team sponsored by the Dell 'Assunta Society, for example, provided an athletic outlet for young men in the community.

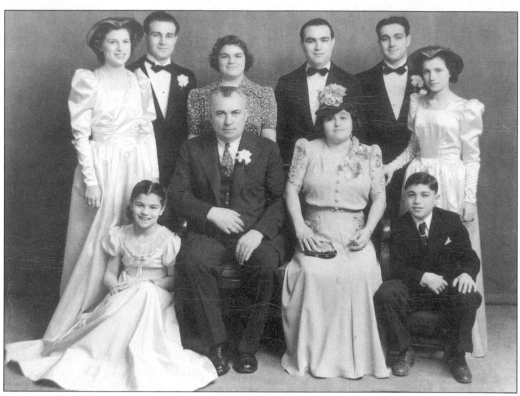

Important family gatherings were occasions for formal family photographs. Posing here is the Zaino family, proprietors of Wheatley Hills, one of Westbury's most popular restaurants.

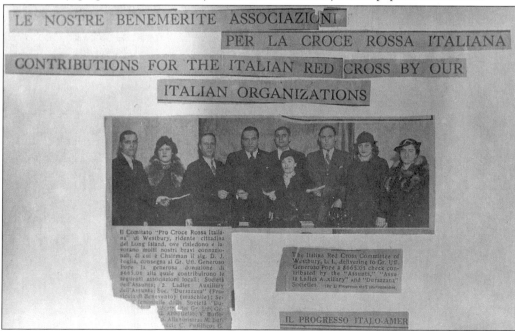

As in many Italian enclaves throughout the United States, Westbury Italian Americans responded to an appeal for support by the Italian Red Cross in the mid-1930s.

While the outbreak of World War II was very worrisome to Westbury Italian Americans who had so many relatives in Italy, there was no question as to their American loyalty. The diary entry of an Italian-born barber in Westbury offers poignant, unstinting evidence of patriotism.

After Italy left the Axis alliance to became an associated power of the Allies, Westbury Italians were engaged in sending clothing to the destitute in Italy.

December. 7-1941 -
172 Post ave. Westbury. Barber -
I am. Italian Born, >>.

Thank you, Uncle Sam, for giving me a name and letting me become an American.
I am proud to be one of you And I shall help in every possible way to Keep America on top of the World.

American Citizen. P. Cesare

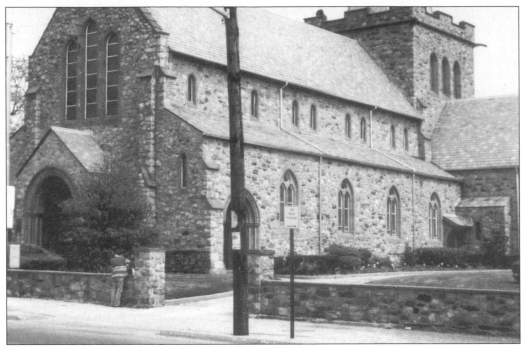

The admirable St. Brigid's Church of Westbury, pictured, is one of the oldest Catholic parishes in Nassau County. Begun by Irish immigrants in mid-19th century, it had developed a lively Italian orientation by the mid-20th century. For years it offered Masses in Italian.

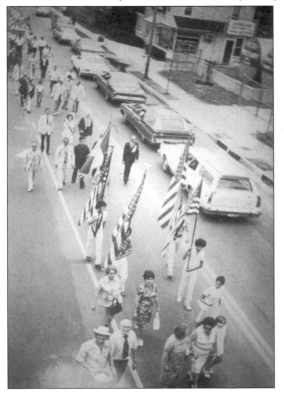

Processions down Westbury's main street continued as a feature of Italian feast celebrations, as evidenced in this 1976 photograph.

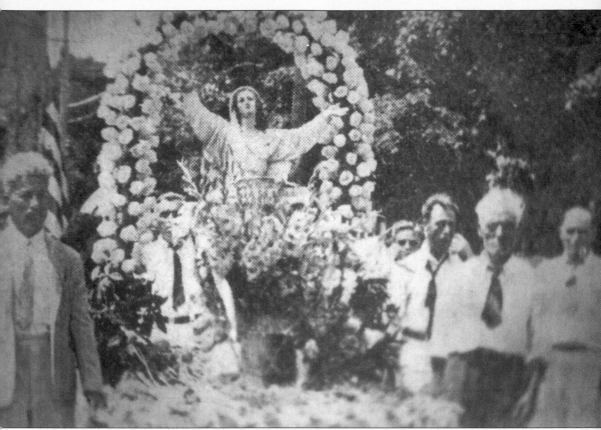

Although many Italian American communities terminated or suspended feast celebrations, the Dell 'Assunta Society continued to hold its feasts emphasizing their religious nature. In this photograph is a procession in which the Blessed Virgin Mary, with outstretched arms, is surrounded by a garland of flowers.

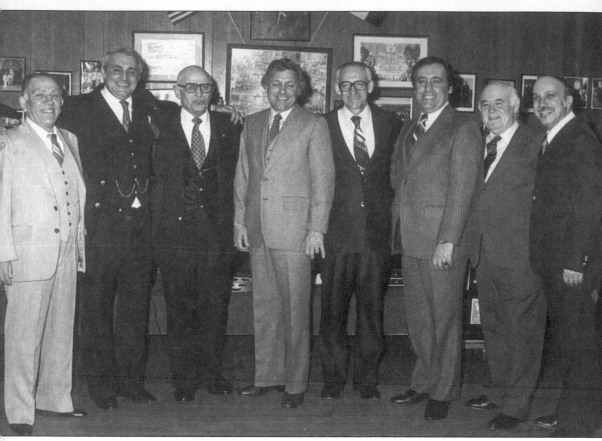

The presidents of three organizations in which Westbury Italian Americans are active are represented in this 1980 photograph. They include, from left to right, Dominic Poscillico of the Durazzano Society; Joseph Piscitelli, Dominic Piscitelli, and Frank Ciardullo of the Dell 'Assunta Society; and Carmine Daddio of St. Anthony's Society. Present also are councilman Charles Fuschillo, Judge Molloy, and Salvatore J. LaGumina.

Four

SUFFOLK COUNTY

At about the same time that Italians found their way into Nassau, they also began to penetrate Suffolk County. Real estate promoters in the Little Italies of New York City advertised desirable land for sale in places like Deer Park, Patchogue, Hagerman, and North Bellport. Before World War I, Giovanni Campagnoli, an enterprising real estate developer, advertised a town he dubbed Marconiville. Not too many years later in the 1920s, noted entrepreneur and newspaper publisher Generoso Pope commended property he called San Remo, in emulation of the famous European community, to the readership of his Italian language daily *Il Progresso Italo-Americano*. Thus a small but significant number of Italian immigrants began their acquaintance with eastern Long Island.

Patchogue was Suffolk's most thriving community in the early 20th century. As a commercial center on the south shore, it possessed small fishing boat yards, small clothing factories, and a large lace-producing mill. The latter industry employed hundreds of Italian Americans, frequently small children of the first and second generation.

Popularly known for decades as Marconiville, the northern portion of Copiague is one of the most fascinating Italian enclaves on Long Island. Named after the famed inventor, this enclave has numerous Italian signs, including street name after street name deliberately given Italian titles such as Marconi, Garibaldi, Verrazzano, Dante, Pio Nono, and Campagnoli. Evidence of Italian background can be found in the churches of Patchogue, Hagerman, and Copiague, where for decades they functioned as de facto Italian parishes.

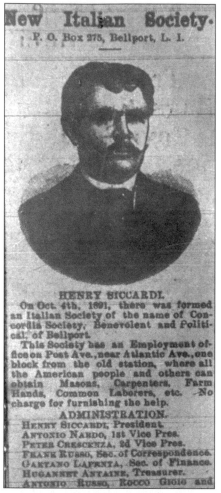

New Italian Society.

P. O. Box 275, Bellport, L. I.

HENRY SICCARDI.

On Oct. 4th, 1891, there was formed an Italian Society of the name of Concordia Society, Benevolent and Political, of Bellport.

This Society has an Employment office on Post Ave., near Atlantic Ave., one block from the old station, where all the American people and others can obtain Masons, Carpenters, Farm Hands, Common Laborers, etc. No charge for furnishing the help.

ADMINISTRATION.

HENRY SICCARDI, President.
ANTONIO NARDO, 1st Vice Pres.
PETER CRESCENZA, 2d Vice Pres.
FRANK RUSSO, Sec. of Correspondence.
GAETANO LAFRATA, Sec. of Finance.
HUGANNET ANTAINE, Treasurer.
ANTONIO RUSSO, ROCCO GIOIO and

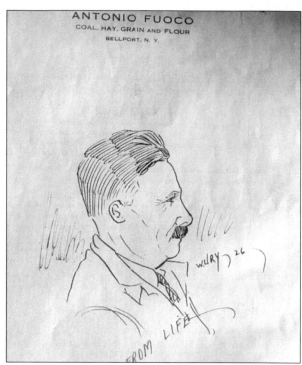

ANTONIO FUOCO
COAL, HAY, GRAIN AND FLOUR
BELLPORT, N. Y.

Left: This newspaper article is convincing evidence of an Italian presence in Bellport in 1891. The notice indicates that the society that was created focused on providing workers. *Above:* Antonio Fuoco was perhaps the first Italian American to settle in Bellport, Long Island. His spacious home was also his place of business, where he sold coal, hay, grain, and flour. It also was the meeting place for Italian American organizations.

The accompanying photograph features the Antonio Fuoco home of Bellport. Descendants of the Fuoco family have maintained a presence in the area for a century.

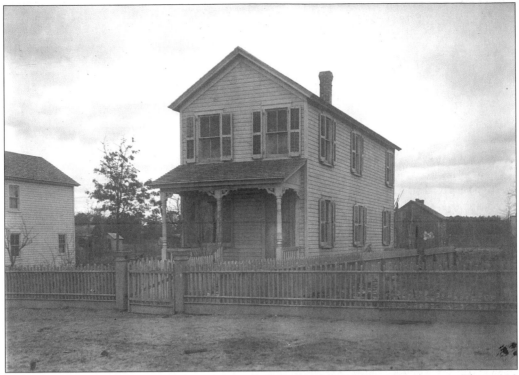

The Felice family was one of the pioneer Italian clans to settle in Patchogue. This 1910 photograph shows the family home, which still stands and is occupied by family members.

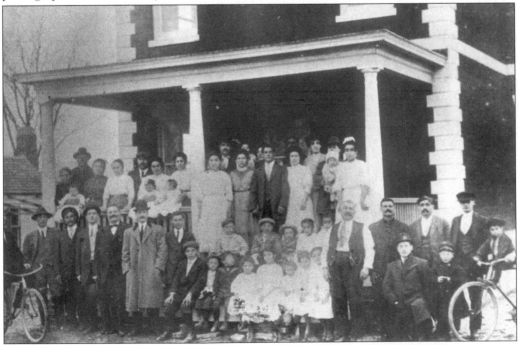

The whole Felice clan, including relatives from New York City, would gather for family celebrations frequently at a Patchogue relative's home.

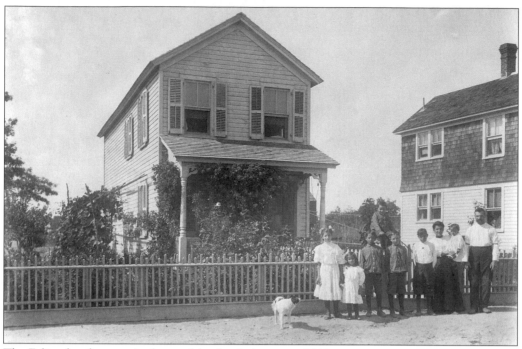

The Felice family poses in front of the family home in 1910.

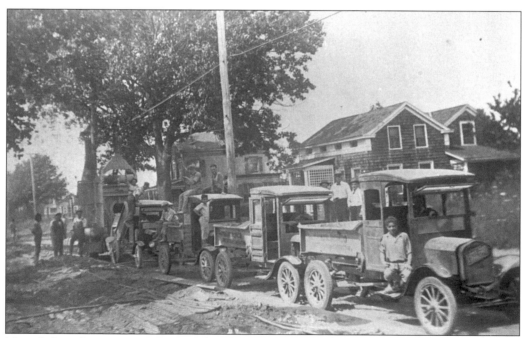

Many Italian Americans were engaged in the construction industry. This photograph shows crews of the Romeo Construction Company preparing the construction of a road in Suffolk County.

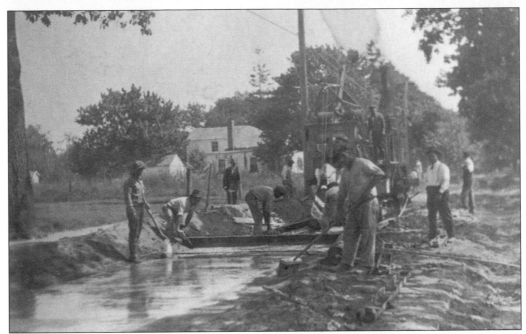

Decades after this picture was taken, members of the Romeo family pointed proudly to the work performed by their family in constructing roads in the Patchogue vicinity.

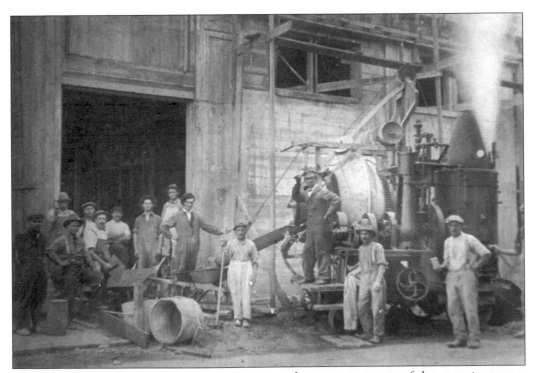

The Romeo Construction Company was contracted to construct some of the more important roads in the town of Brookhaven, such as Route 112. This photograph shows a number of employees next to large equipment used in road building in the 1920s.

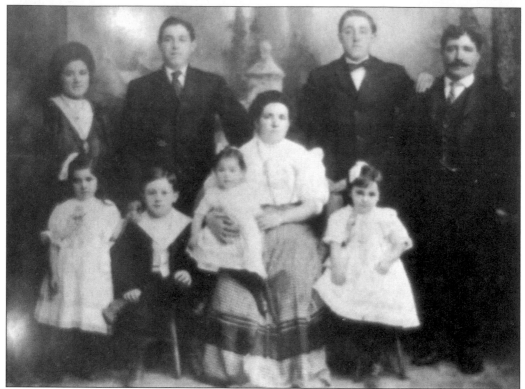

For many years, the Prudente family of Patchogue was prominent in local affairs. This photograph of the family was taken in the early part of the 20th century.

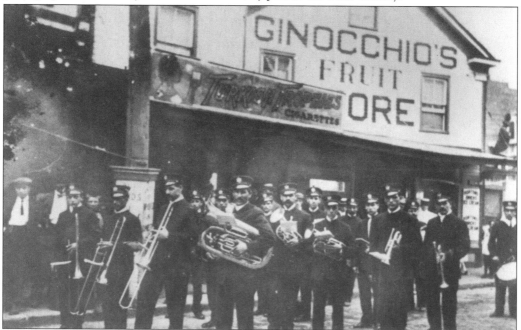

As in other Italian communities, Italian bands were features of special occasions. This photograph shows a local Patchogue band playing in front of Ginocchio's Fruit Store.

MRS. CARMELA RUSSO

North Bellport, L. I.

Telephone 7-M Bellport

LICENSED MIDWIFE

20 Years Experience Prompt Service

LA SIGNORA CARMELA RUSSO

Levatrice Apatentata Italiana

North Bellport, L. I.

Midwives were extensively used in Europe. The practice continued in this country, as this advertisement in English and Italian demonstrates.

Saint of Mount Carmel

CELEBRATION

To Be Held at the Italian Section of Hagerman, L. I.

On Thursday, Friday, Saturday and Sunday, July 14, 15, 16, 17

For the Benefit of

St. Joseph's Catholic Church of Hagerman

BIG FIREWORKS DISPLAY

(On Sunday Night Only)

MUSIC FOR BLOCK PARTY FURNISHED BY ELKS' BAND

From 1 P. M. to 12 Midnight

Bring Your Family **Tell Your Friends**

Under Management of ANTONIO FUOCO

Local newspapers advertised the Feast of Mount Carmel to be held in 1926 at St. Joseph's Church in Hagerman's Italian section. Stunning but boisterous fireworks were common sights in feast day celebrations. Notice the influence of Antonio Fuoco, who organized these events.

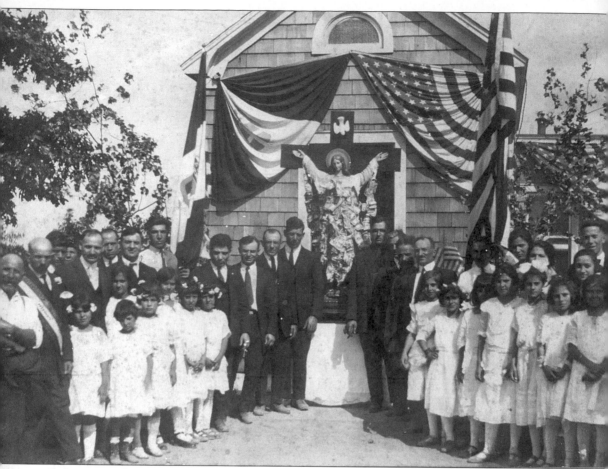

Religious traditions of the old country were dear to Patchogue's Italians. Pictured in this photograph is the statue of St. Liberata in front of the house of Carmine Bianco (second from the left with the sash). For decades, he was the prime mover of the feast.

A Church of God Pentecostal church in Patchogue offered services in Italian and English in the 1930s.

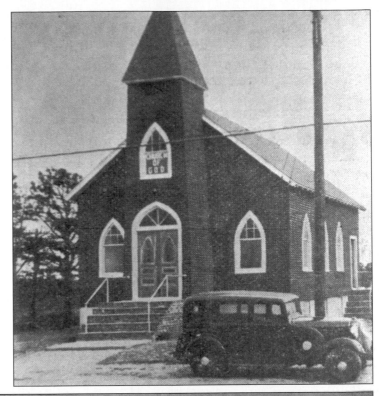

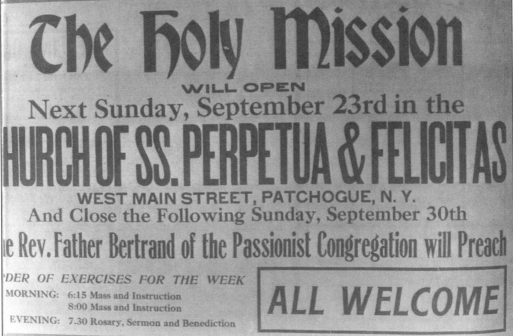

The Holy Mission

WILL OPEN
Next Sunday, September 23rd in the
HURCH OF SS. PERPETUA & FELICITAS
WEST MAIN STREET, PATCHOGUE, N. Y.
And Close the Following Sunday, September 30th

e Rev. Father Bertrand of the Passionist Congregation will Preach

DER OF EXERCISES FOR THE WEEK

MORNING: 6:15 Mass and Instruction
 8:00 Mass and Instruction
EVENING: 7.30 Rosary, Sermon and Benediction

ALL WELCOME

In Patchogue, Italian Americans were associated with Our Lady of Mount Carmel Catholic Church, which for years operated as a de facto Italian ethnic parish. It was originally called SS. Perpetua and Felicitas, as this announcement shows.

Born in Coscenza, Italy, Joseph Cardamone became a leader among Patchogue's Italian Americans. He was instrumental in founding the Italian American Civic League of Long Island that sought to promote Americanism and citizenship.

Fr. Cyrus Tortora, beloved pastor of Our Lady of Mount Carmel (1943–1953), made the deepest impact on the Patchogue area. He provided recreational facilities for the young, served as chaplain for a nearby army camp, and precipitated ecumenism by working with other religious leaders for the good of the community.

The aim of this advertisement was to lure residents of Little Italies in New York City to Deer Park. It held out as prominent features proximity to the big city via the railroad, nearby grocery and other stores for shopping, a church, hotel, and a lake with abundant fish. For a sum of $30, one could obtain a lot 25 by 100 feet.

DEER PARK IMPROVEMENT CO.,
BENNETT BUILDING
Angolo di Nassau & Fulton Sts., N. Y. — Rooms 909 A 68.
Capitale $100,000.

This is a view of a main street in Copiague (Marconiville) at the time Italians first starting moving into the area. Note that the avenue is bereft of many conveniences, such as sidewalks and paved streets.

P. Andreoli e F. C. Belsito,
BANCA F.lli LA MAIDA & CO.
124 Mulberry St., e 2914 1st Ave., N. Y.

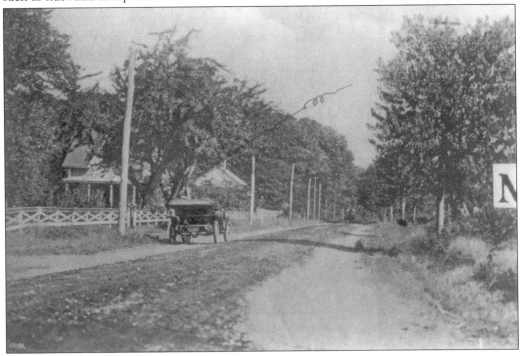

This photograph shows Italian Americans working in construction in the Amityville area in the 1930s.

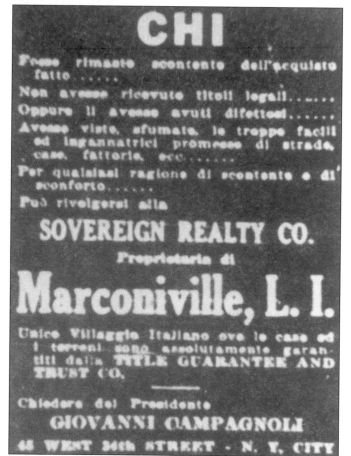

A newspaper advertisement in *Il Progresso Italo Americano*, the largest Italian language daily in the country, features land for sale in Marconiville. In an effort to entice prospective buyers, the commercial alluded to an Italian village near the sea with abundant water, electricity, gas, transportation, and a school.

Giovanni Campagnoli, a former classmate of world-famous inventor of the wireless, Guglielmo Marconi, promoted the area as an "Italian village."

Campagnoli had real estate offices in New York City and in Copiague, as pictured below. He promoted Marconiville in New York's Little Italies as a healthy, economical Italian town that offered work, water, gas, electricity, school, electric trolleys, and a railroad station.

MARCONIVILLE, L. I.
Ameno villaggio Italiano vicino al mare.
Economia—Salute—Lavoro—Acqua—Gas—Luce elettrica—
Scuola—Carro elettrico—Stazione sulla proprietà
Case e Lotti a condizioni vantaggiose. Rivolgersi al
Presidente della
SOVEREIGN REALTY COMPANY,
GIOVANNI CAMPAGNOLI, 45 W. 34th Street, New York.

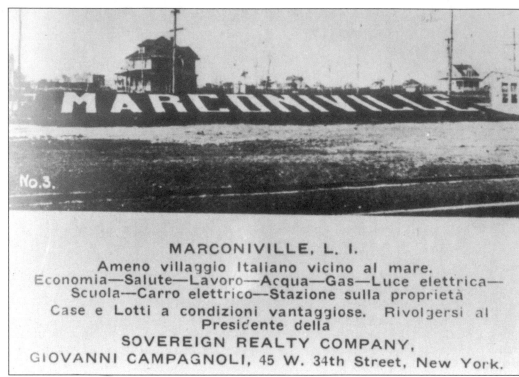

No. 3.

MARCONIVILLE, L. I.
Ameno villaggio Italiano vicino al mare.
Economia—Salute—Lavoro—Acqua—Gas—Luce elettrica—
Scuola—Carro elettrico—Stazione sulla proprietà
Case e Lotti a condizioni vantaggiose. Rivolgersi al
Presidente della
SOVEREIGN REALTY COMPANY,
GIOVANNI CAMPAGNOLI, 45 W. 34th Street, New York.

Large letters spelling out Marconiville were visible for many years in front of Copiague's Long Island Railroad station. The name designation lasted until about the time of World War II.

Charles Barcelona, one of the earliest Italian American settlers in Copiague, became a deputy sheriff. His home was one of the more handsome residences in the area.

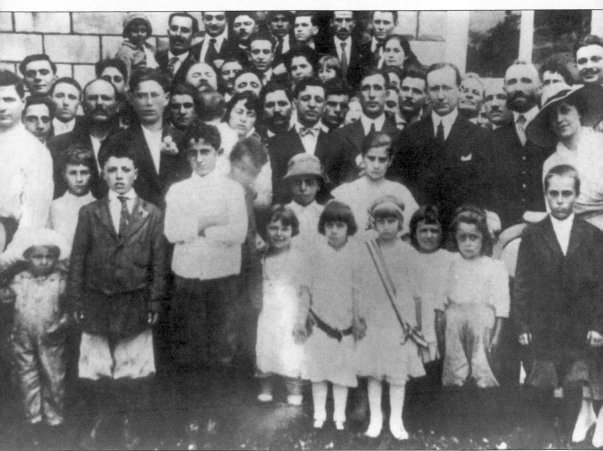

In an effort to encourage settlement of Marconiville, Campagnoli was able to get Marconi to visit the town. The inventor is shown in this 1917 picture (fifth from the right, second row). Virtually all the town's Italians came to greet him.

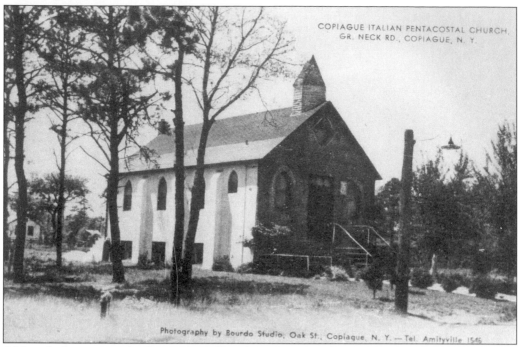

Although the present-day Pentecostal Church in Copiague does not contain the word "Italian" in its title, it originated as the Copiague Italian Pentecostal Church.

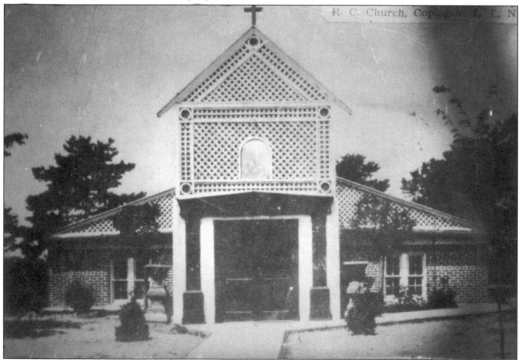

In the absence of a local Catholic Church, Italian Catholics were instrumental in starting Our Lady of the Assumption. This photograph shows a temporary facility that eventually was replaced by a permanent structure.

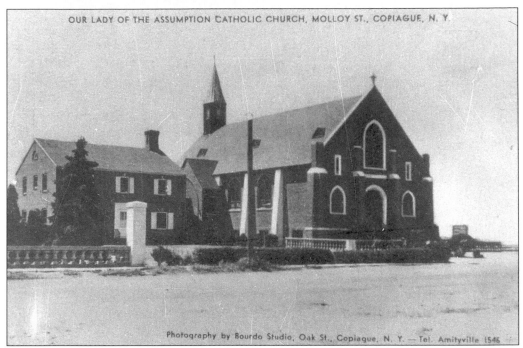

For decades, Copiague's Our Lady of the Assumption Church was perceived as an Italian parish. The perception was attenuated by the appointment of Italian Americans pastors for about the first 40 years until demographic changes occurred.

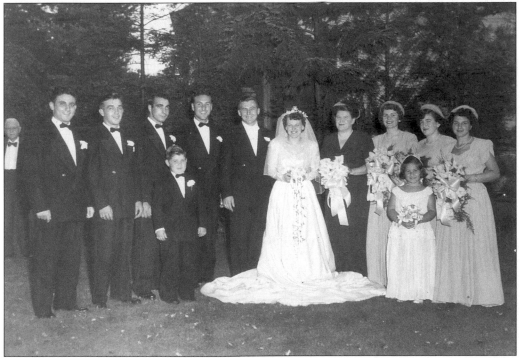

The increase in Copiague's population immediately after World War II found increases in marriages. This photograph shows an Italian American couple on their wedding day in 1950.

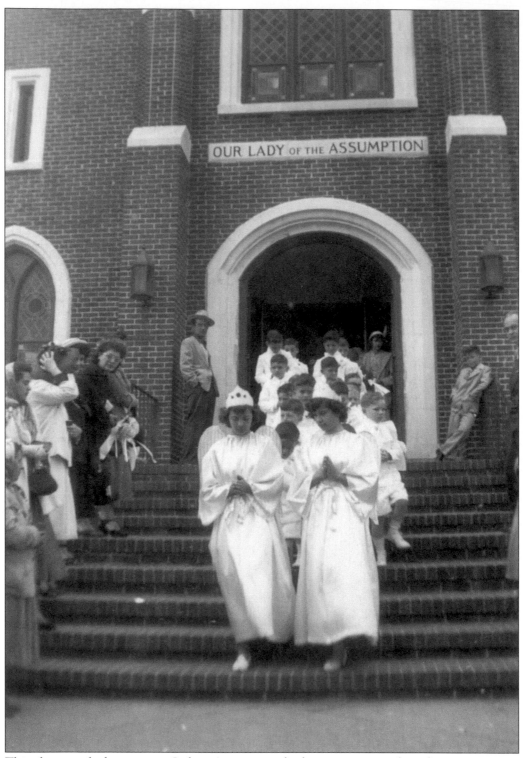

This photograph shows young Italian Americans who have just received confirmation coming down the stairs of Our Lady of the Assumption Church in Copiague in the early 1950s.

Scenes such as this one showing Italian American servicemen from Copiague on leave were common sights in the early 1950s during the Korean War.

The increased role of Copiague's Italian Americans is reflected in this photograph of John Miranda, who served as chief of the Copiague Fire Department in the 1950s.

Losi's, founded in Amityville in 1900, had one of the longest tenures of Italian American businesses. Started by immigrant Anton Figari, Louis Losi became confectioner-proprietor and ran the business until well into the second half of the century. It was the first in town to install electric lights.

In the 1920s, a builder began the American Venice development in Lindenhurst. Designed as a replica of Venice, Italy, it featured canals, arched bridges, and street names evocative of ancient Venice. To promote the development, real estate agents hoped to lure people, especially Italian Americans, with gondola rides. Two famous arch bridges of that era continue to serve the community.

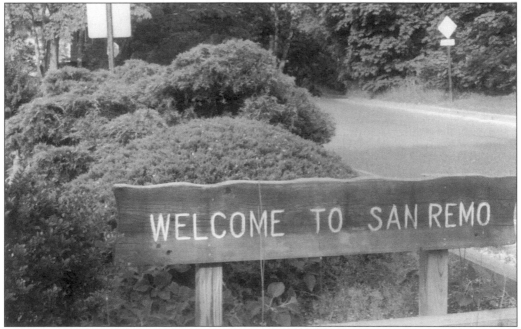

Although San Remo today betrays few visible signs of its Italian past, it still has a substantial population. Some of them are descendants of an earlier time in the 1920s, when Generoso Pope and other Italian American entrepreneurs promoted sale of this land among Italian Americans. As an enticement, a three-year subscription to *Il Progresso Italo Americano* gave one title to a 20-by-100-foot plot.

The wave of Italian immigration after World War II saw a number of Sicilians settle on Long Island, where they started small businesses. One example is Peter Maccarone, who excels in providing pizza and other Italian food in Taormina's Restaurant, Commack.

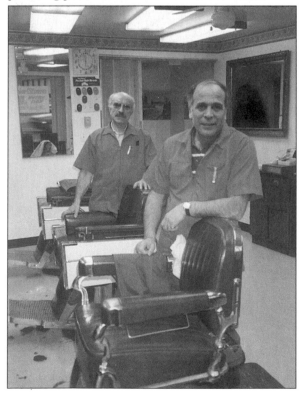

Carrying on the barbering trade learned in the old country, George Mundi poses with another Italian immigrant in his barbershop that operated in Patchogue for many years.

Five

ITALIAN SIGNS AND MARKS

Signs of an Italian influence of the past remain extant in present-day Long Island. They are conspicuous in a number of ways, as in the street names of communities such as Inwood, Glen Cove, and Copiague. They are obvious in stately pillars with the Lion of Venice along Merrick Road and in the ornate grillwork with the name "Marconiville" in Copiague. They endure in distinctive construction projects such as small arched bridges in some south shore waterfront communities. They remain in the preservation of the shack used by Marconi to send wireless messages across the ocean. Signs of Long Island's Italian past also survive in the construction of statuary gracing the Oyster Bay Post Office, where skilled Italian artisans worked, and endure in functioning ethnic society halls constructed by the immigrants.

In the 1920s, real estate agents promoted the American Venice development along Suffolk's south shore. Guarding the entrance to the development were two statuesque towers with winged lions on their pedestals. This one still stands on Merrick Road between Lindenhurst and Copiague.

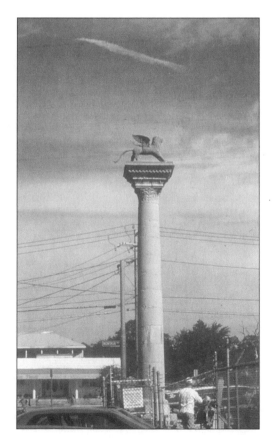

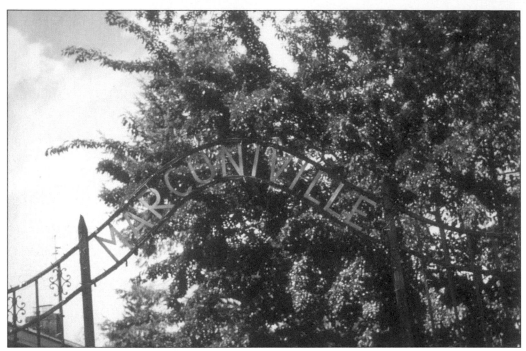

The intricate cast-iron grillwork that graces the archway to a business establishment retains the Marconiville name.

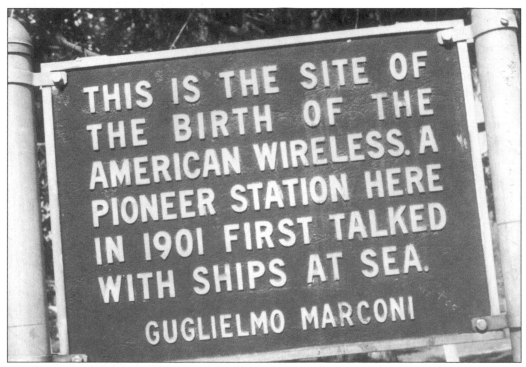

THIS IS THE SITE OF THE BIRTH OF THE AMERICAN WIRELESS. A PIONEER STATION HERE IN 1901 FIRST TALKED WITH SHIPS AT SEA.

GUGLIELMO MARCONI

This historic marker located on Fire Island Avenue in Babylon stands as an enduring reminder of the impact the Italian inventor had on Long Island.

This photograph of a sturdy monument in a small park area before the Copiague Railroad station is a reminder of Italian American loyalty during World War I.

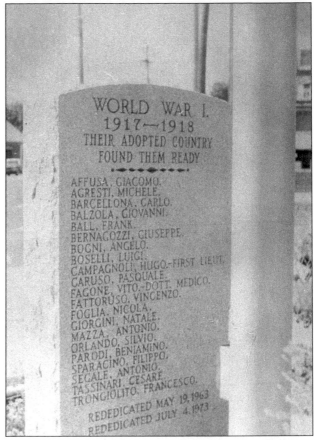

WORLD WAR I.
1917—1918
THEIR ADOPTED COUNTRY
FOUND THEM READY

AFFUSA, GIACOMO.
AGRESTI, MICHELE.
BARCELLONA, CARLO.
BALZOLA, GIOVANNI.
BALL, FRANK.
BERNAGOZZI, GIUSEPPE.
BOGNI, ANGELO.
BOSELLI, LUIGI.
CAMPAGNOLI, HUGO.-FIRST LIEUT.
CARUSO, PASQUALE.
FAGONE, VITO.-DOTT. MEDICO.
FATTORUSO, VINCENZO.
FOGLIA, NICOLA.
GIORGINI, NATALE.
MAZZA, ANTONIO.
ORLANDO, SILVIO.
PARODI, BENIAMINO.
SPARACINO, FILIPPO.
SEGALE, ANTONIO.
TASSINARI, CESARE.
TRONGIOLITO, FRANCESCO.

REDEDICATED MAY 19, 1963
REDEDICATED JULY 4, 1973

By 1980, about 40 percent of Elmont, Long Island, was Italian American. Evidence of the heavy Italianitá of the community is visible in this stone marker encased in one of the homes.

GUISEPPE
BELLASPERANZA
MAY 28 1936

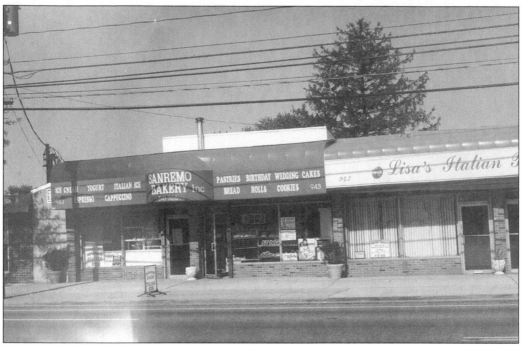

Virtually every Long Island Italian enclave has an Italian bread store. With about one-third of its residents of Italian ancestry, Massapequa features the San Remo Bakery.

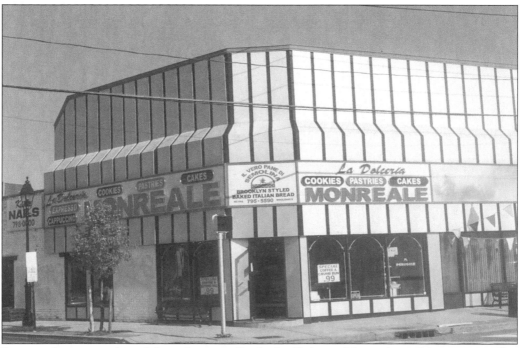

Bearing the name of a celebrated city in Sicily, La Dolceria Monreale in Massapequa offers customers genuine Brooklyn Italian semolina bread as well as other traditional Italian pastries.

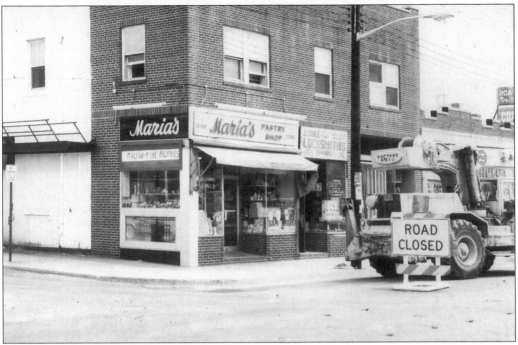

Maria's Pastry Shop in Westbury is typical of superb Italian stores that can be found in numerous towns on Long Island. Long lines are common at holiday time.

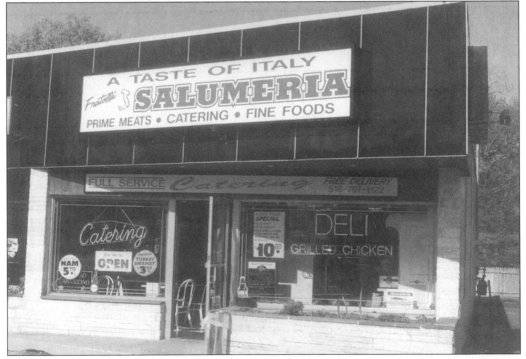

Italian food is a common favorite for many Long Island office and home functions. Numerous catering houses, such as the "taste of Italy" Salumeria store on Broadway in Massapequa, specialize in this trade.

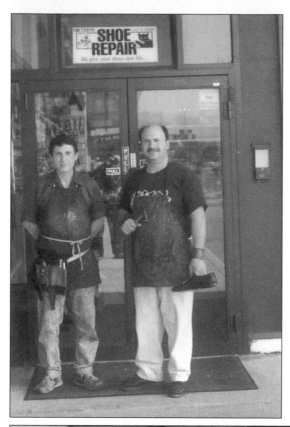

Small shoemaker shops that were common sights in all of the country's Little Italies enabled many immigrants to provide a livelihood for their families. Although their presence has diminished, some shops—such as the one run by Palermo-born Roy (Rosario) Tipa and his brother, Joseph, in a Massapequa shopping center—continue the trade.

Crusty Italian bread, canned tomatoes and hero sandwiches are popular features in many Long Island delicatessens, such as this one in Westbury in 1977.

In this photograph, Andrew Mercurio proudly carries on the tradition of making mozzarella cheese.

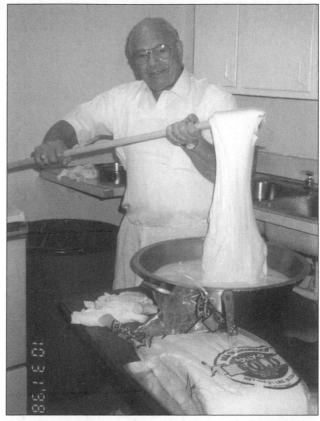

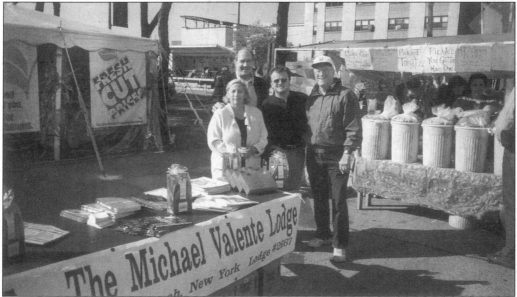

Constantino Sagonas, Carol Arnone, Joe Sinnona, and Doug Davies of the Michael Valente Sons of Italy Lodge in Long Beach, celebrate Italian heritage by making Italian food available. Valente, of Long Beach, was an Italian American Congressional Medal of Honor recipient for his valor during World War I.

Special Italian American functions on Long Island regularly feature abundance of Italian American food.

Long Island Sons of Italy members visit the Meucci-Garibaldi Museum in Staten Island. Meucci is often given credit for being the inventor of the telephone, while Garibaldi was the hero of Italian unification who lived for a time in Staten Island.

Shown in this 1998 photograph are members of the John J. Marino Lodge of Port Washington learning about their ancestors' voyage from Italy to Ellis Island.

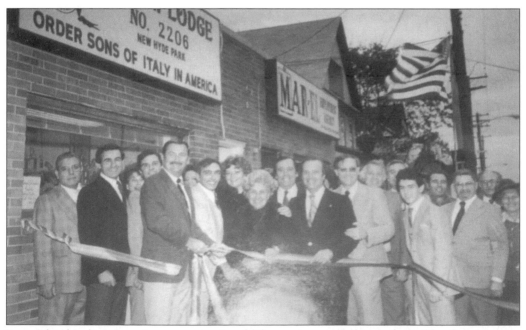

Long Island Italian American organizational life remains spirited, as indicated by the existence and activities of numerous groups. In the two generations following World War II, many Sons of Italy chapters on Long Island were formed. This photograph shows the opening of the Cellini Lodge in New Hyde Park.

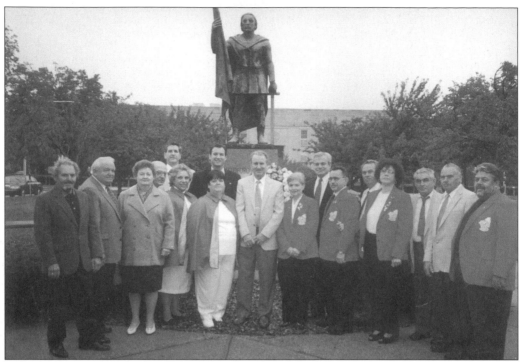

Pictured is a group of Italian Americans from Glen Cove and Port Washington. They are laying a wreath before the Columbus Monument in Mineola. Two Italian American political figures—Thomas Suozzi, mayor of Glen Cove, and Thomas Gulotta, Nassau County executive—are in the back row.

Placing a wreath honoring Christopher Columbus are Joseph Cangemi and Joseph Caputo (second and third from left).

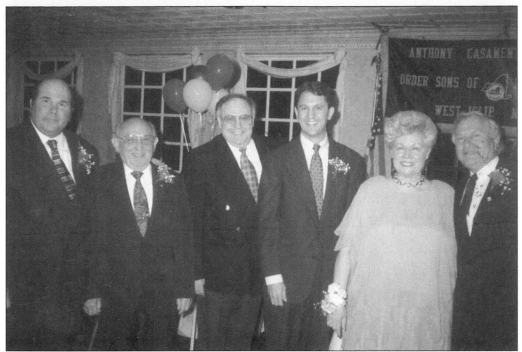

Officers of Casamento Lodge—named after World War II Congressional Medal of Honor winner Anthony Casamento—extend tribute to Rep. Rick Lazio (fourth from left) of Suffolk County.

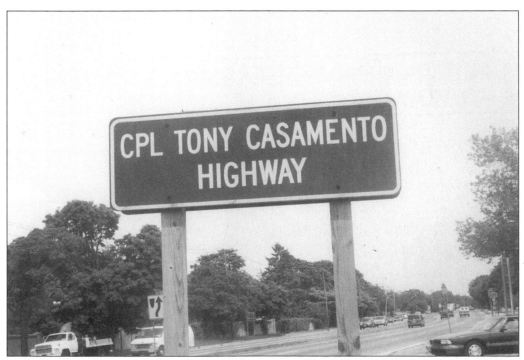

Cpl. Tony Casamento Boulevard, on Route 109 in West Babylon acknowledges the Italian American World War II hero.

Italian American Night has become a regular feature of ethnic group recognition in Nassau County. Here, county executive Thomas Gulotta presents awards to various Italian Americans.

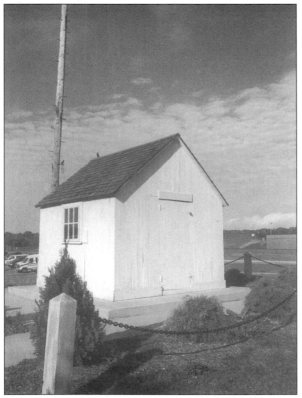

The historic 1902 Guglielmo Marconi radio sending station, which was originally in Babylon, is presently located at the Frank J. Carasiti School on Marconi Boulevard in Rocky Point. Restored by Rosario Aurucci, the shack originally served as a ship-to-shore communication facility and a training school for wireless operators.

Bocce continues as a favorite form of entertainment for Long Island Italian Americans. Pictured are happy members of New Hyde Park's Cellini Lodge enjoying the game of their ancestors.

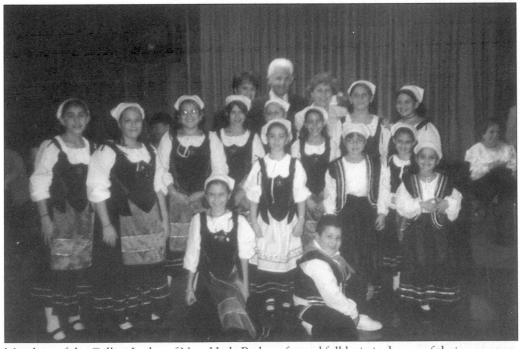

Members of the Cellini Lodge of New Hyde Park performed folkloristic dances of their ancestors.

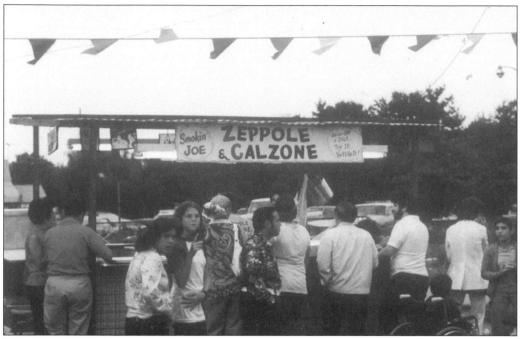

Zeppole and calzone, traditional Italian foods, are featured at St. Anthony's Feast in Hicksville, Long Island.

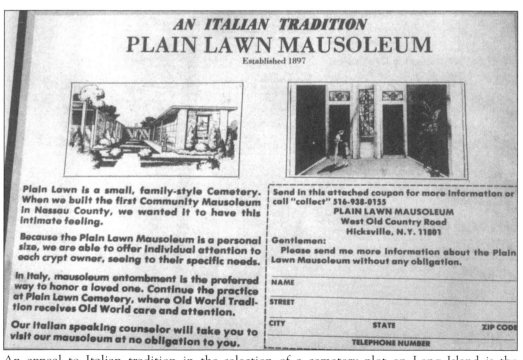

An appeal to Italian tradition in the selection of a cemetery plot on Long Island is the fascinating message in this advertisement.

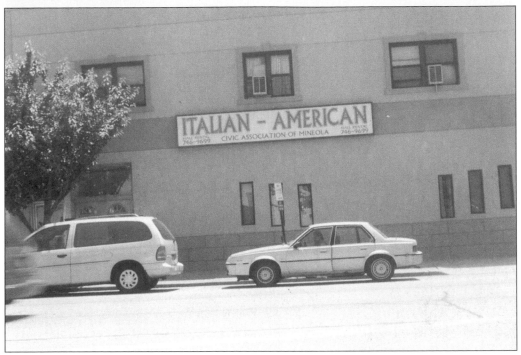

In this photograph, the Italian American Civic Club of Mineola displays a large sign at its headquarters on Jericho Turnpike.

The Centro Culturale serves Italian Americans in the West Babylon area.

ITALIAN IMMIGRANT WELFARE ORGANIZATION
FREE SOCIAL ASSISTANCE & COUNSELING
PATRONATO
INCAUSA
UFFICIO PENSIONI

Assistance for Italian immigrants is available at the Centro Culturale in West Babylon.

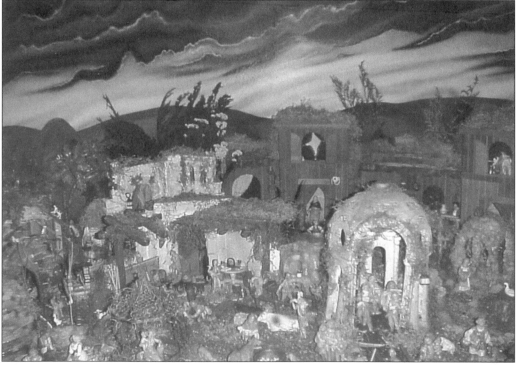

At Christmastime in 1998, Fr. Gerald Cestare displayed *"Il Presepio"* at Our Lady of Grace Catholic Church, West Babylon. Proud of carrying on a centuries-old tradition from Italy handed down to him by his grandfather, Father Cestare added his own figures to the display.

Several Long Island towns have Columbus statues. One of the most impressive is in Huntington, shown here.

Members of the Dell' Assunta Society of Westbury assemble to cut the ribbon marking the rededication of Dell' Assunta Hall in 1986.

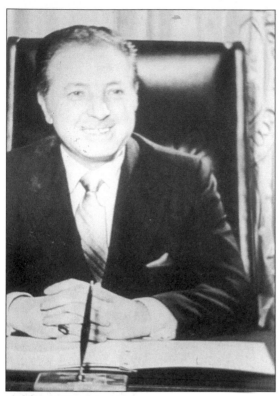

This photograph shows Ralph Caso of Merrick, who in 1970 was the first Italian American elected to be Nassau County executive. He later ran for lieutenant governor of New York.

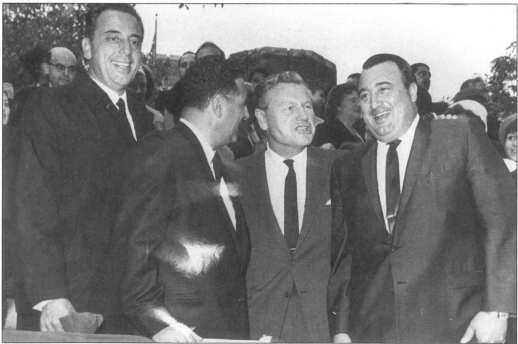

This photograph shows, from left to right, Fortune Pope (publisher of *Il Progresso Italo Americano*) and Robert Curcio of Copiague (Suffolk County Republican leader) talking to Gov. Nelson Rockefeller during a campaign swing in Copiague.

Robert Curcio of Copiague was the
first Italian American Suffolk
County Republican leader. Here, he
is shown busy on the phone while
having his hair cut.

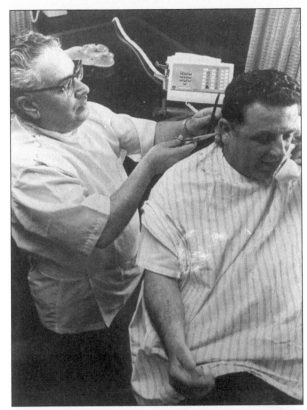

The current Nassau County
executive, Thomas Gulotta (second
from right), is shown below making a
presentation. He is the son of Frank
Gulotta. The others in the
photograph are unidentified.

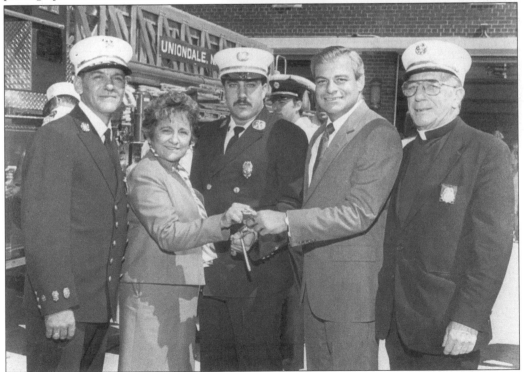

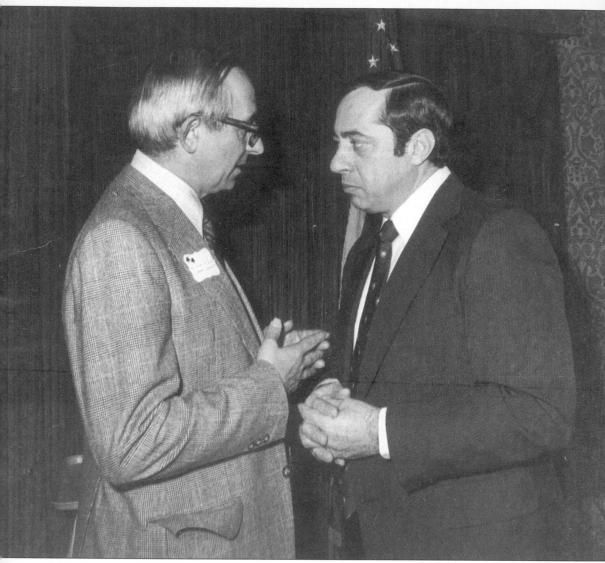

Mayor Vincent Suozzi of Glen Cove confers with Mario Cuomo, future governor of New York, in 1978. Vincent's brother, Joseph, served as mayor before him, while the current mayor is his nephew, Thomas Suozzi.

Six

CONTEMPORARY ITALIAN AMERICAN LIFE

By the end of the 20th century, the U.S. census indicated that slightly more than one of every four (27 percent according the 1990 census) inhabitants of Nassau and Suffolk were of Italian background in whole or in part. In many communities, they represented 30 percent or more of the population, while in some, such as Elmont and Deer Park, they accounted for approximately 40 percent. Americans of Italian descent are conspicuous in many walks of life, from politics to social and cultural activities. Italian American organizations abound, and the study of the Italian American experience has become the focus of academic institutions. Numerous religious feasts and other community celebrations with Italian flavor take place annually. Unique Italian recreational activities, such as bocce, remain part of the contemporary scene.

The Commission for Social Justice (CSJ), an arm of the Order of the Sons of Italy, honors assemblyman and Nassau Democratic leader Thomas DiNapoli of Great Neck and Sen. Seraphim Maltese of Queens in 1998. Representing the CSJ are Josephine Morice Cohen and Joseph Cangemi, state president.

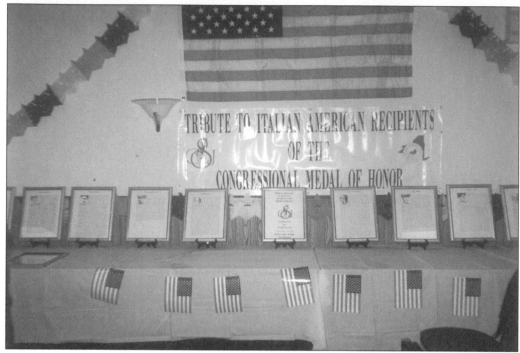

In a meritorious effort to counter negative stereotypes about Italian Americans, the Commission for Social Justice created a major display: Italian American recipients of the Congressional Medal of Honor. From the 1990s to today, this display has appeared in many programs on Long Island.

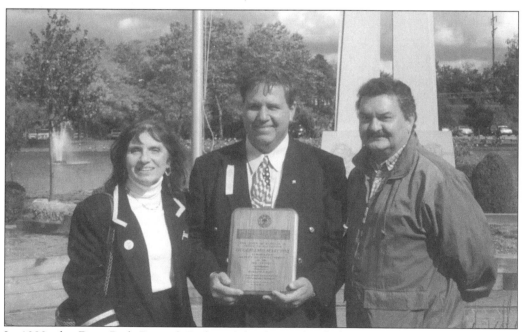

In 1999, the Deer Park Brumidi Lodge of the Sons of Italy honored the memory of the late Anthony Casamento, former lodge member and Congressional Medal of Honor winner.

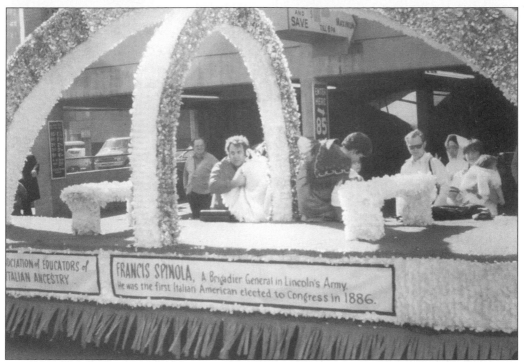

Born in Stony Brook, Long Island, early in the 19th century, Francis B. Spinola had a distinguished career as a Civil War general and was the first of his nationality elected to Congress. His career is recalled in this floral display during a Columbus Day parade in 1978.

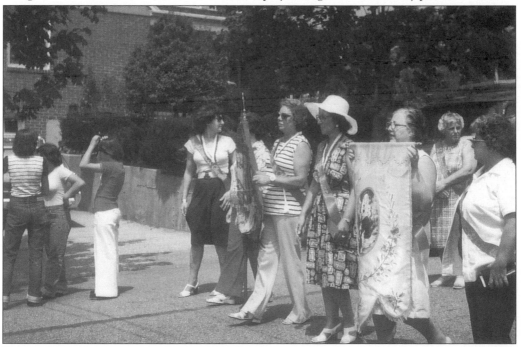

Religious processions continue in Long Island, as indicated in this 1977 photograph of St. Rocco Church members in Glen Cove.

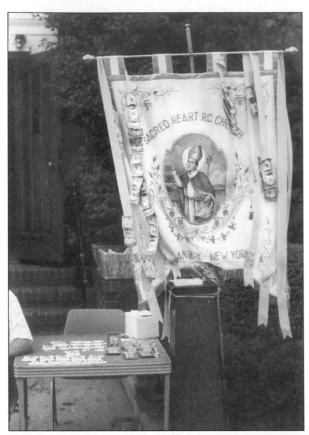

The banner shown in this 1975 photograph reveals the high regard for the Feast of San Gennaro in Island Park, Long Island.

The tradition of celebrating the Feast of San Gennaro continues. This 1999 photograph shows Bishop James McHugh and Fr. John Tutone, pastor of Sacred Heart Church, in Island Park at the festival opening.

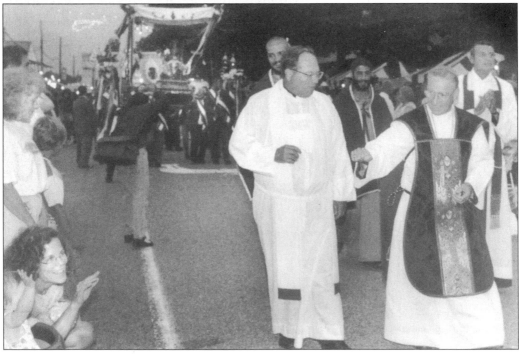

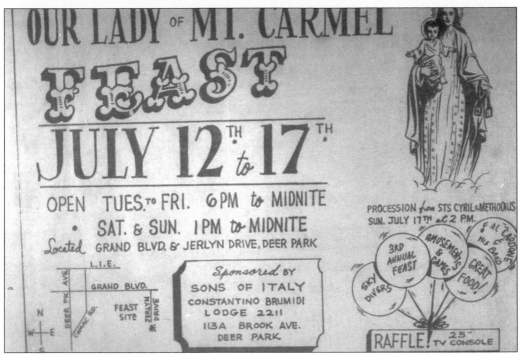

This 1980 poster illustrates the commingling of religious feasts and Italian organizations such as the Sons of Italy.

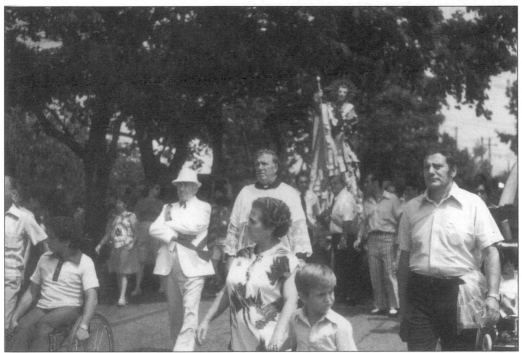

This spiritual procession proceeds along Glen Cove's Buena Vista Street during the 1977 St. Rocco's Feast.

ST. ROCCO'S ITALIAN FEAST
GLEN COVE, N.Y.
JULY 27th, 28th, 29th, 30th and 31st, 1977
on
ST. ROCCO'S CHURCH GROUNDS, THIRD ST.

ITALIAN SINGERS, BANDS, ITALIAN FOODS, BOOTHS RIDES, GAMES AND FIREWORKS.
SPIRITUAL PROCESSION SUNDAY AFTER 12:00 NOON MASS COME EAT, DRINK AND BE MERRY WITH US.

THE FEAST OPENS NITELY AT 6:00 P.M.

NO ADMISSION CHARGE **FUN FOR ALL AGES**

For decades, St. Rocco's Feast endures as one of the most popular celebrations of its kind on Long Island.

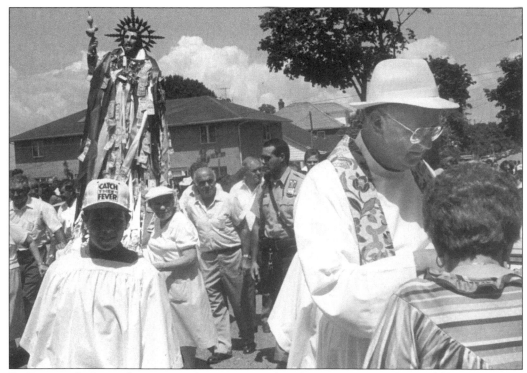

Fr. Domenick Graziadio, pastor of St. Rocco's Church, passes out medals and blesses the sick during the annual parish feast in 1993.

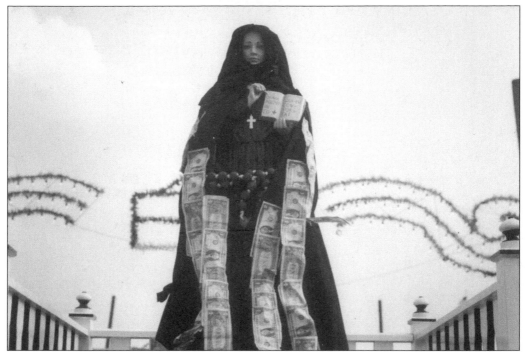

Italian-born Mother Francesca Cabrini, a champion of Italian immigrants in the early 1900s, was the first American citizen to be recognized as a saint in the Catholic Church. As evidenced in this 1977 photograph, Long Islanders celebrate her feast day in Brentwood with a procession of her statue and money pinned on her in the traditional Italian way.

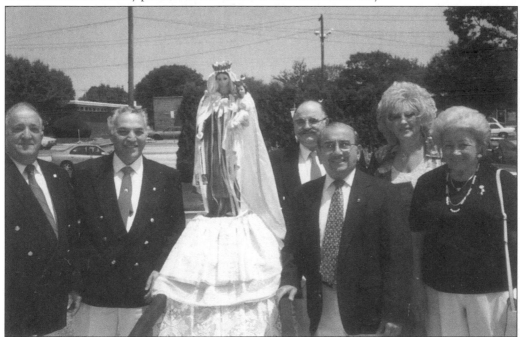

Sons of Italy members are shown in this photograph. They attended Mass at St. Cyril Church, Deer Park, and celebrate Our Lady of Mount Carmel, whose statue they surround.

Respected for her writings on Italian American women, Helen Barolini addresses audience of the Long Island Chapter of the American Italian Historical Association in West Hempstead in 1988.

Esteemed poet Joseph Tusiani, whose works shows true sensitivity for the Italian soul, is shown speaking before the Long Island Chapter of the American Italian Historical Association in 1986.

Movie, radio, and television personality Floyd Vivino (fourth from the left), who has made Italian ethnic humor a staple of his comedy, has appeared many times before Long Island audiences.

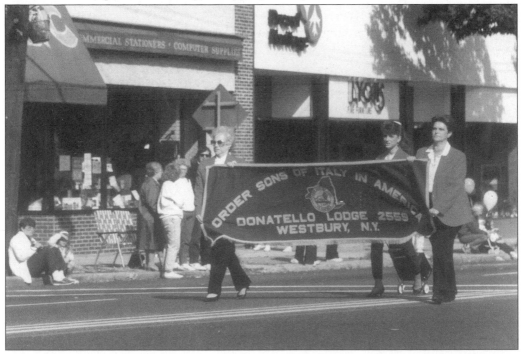

This view shows members of the Donatello Lodge of Westbury marching on Columbus Day.

Jubilance is evident among Sons of Italy members during Columbus Day 1999.

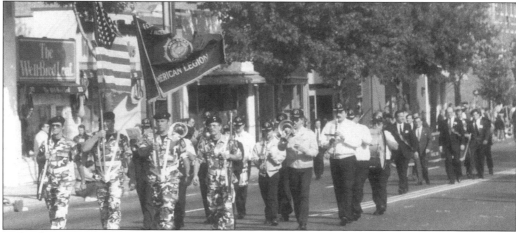

Columbus Day celebrations brought contingents from such organizations as the American Legion, as is shown in this 1988 photograph taken in Huntington.

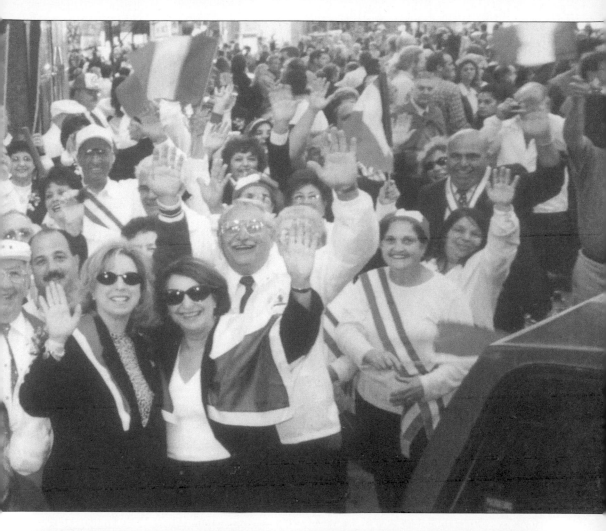

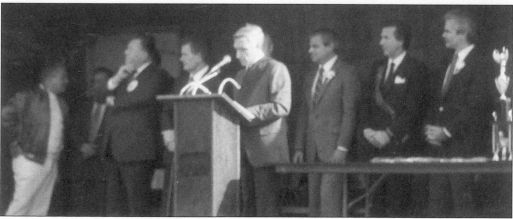

In this 1988 photograph, Joseph Sciame, the state president of the Sons of Italy, addresses a Columbus Day crowd. Standing in the background are Thomas Gulotta, Nassau County executive (third from the right) and Peter Halpin, Suffolk County executive (far right).

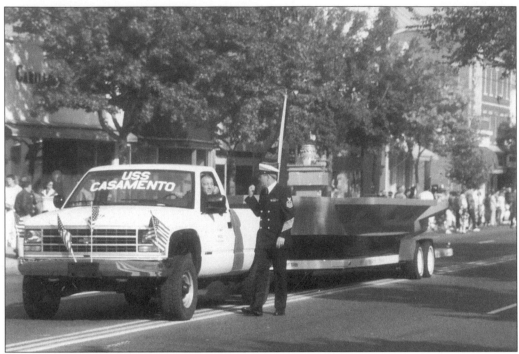

This float commemorating Anthony Casamento is part of a Columbus Day parade in Huntington.

Long Island Sons of Italy members are shown on a bus en route to participate in New York City's major Columbus Day celebration in 1999.

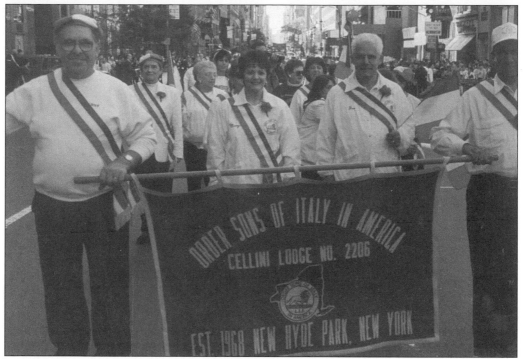

Decked out with their Cellini Lodge banner and red, white, and green sashes, New Hyde Park Sons of Italy members march in festive Columbus Day parade.

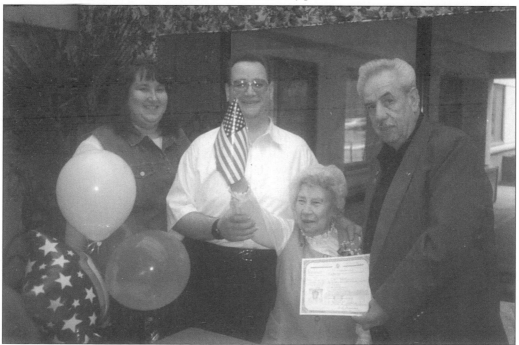

On April 16, 1999, some 74 years after she came to the United States from Palermo, 86-year-old Mary Loccisano, became an American citizen. Here, family members rejoice with her in the Brookhaven Care Facility.

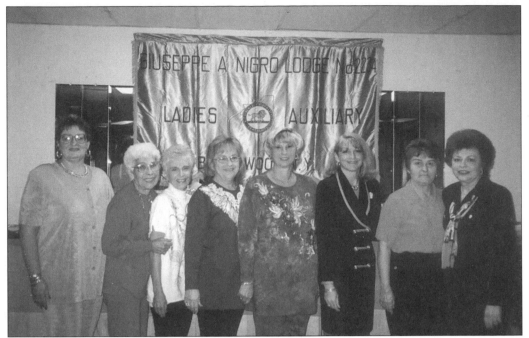

Ladies Auxiliary members of the Giuseppe A. Nigro Lodge pose in this photograph. Nigro, an immigrant from Sturno, Italy, became a highly successful businessman in Glen Cove and an active member of the Sons of Italy.

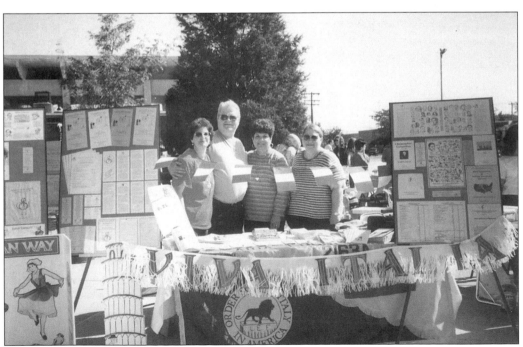

Promoting knowledge about Italian and Italian American accomplishments is a major interest of these Sons of Italy members at the Hofstra University Italian Fair.

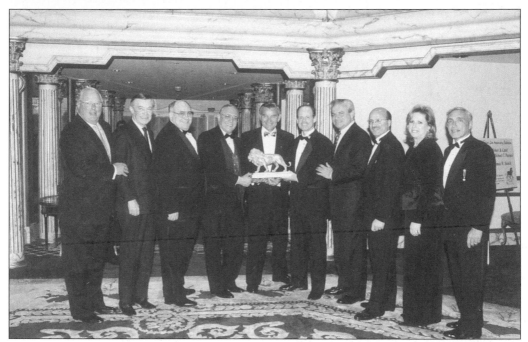

Formal dinners are frequent occasion for Sons of Italy members to gather together and raise funds for worthy causes. Pictured are several officers of the organization, including Joseph Cangemi, Sons of Italy state president (third from the left) and dignitaries such as Thomas Gulotta, Nassau County executive (fourth from the right).

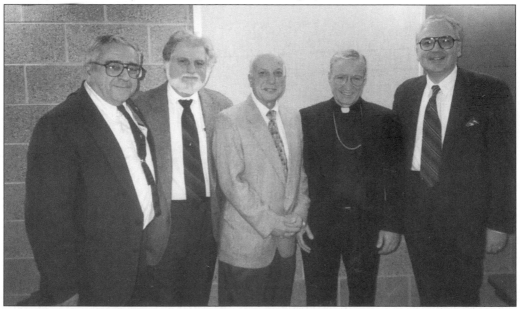

In 1999, the Italian Studies Center of Stony Brook University hosted a reception in recognition of its publication of *The Saints in the Lives of Italian Americans*. The co-editors shown, from left to right, are Donald D'Elia, Salvatore Primeggia, Salvatore J. LaGumina, and Joseph Varacalli. In his address, Rockville Centre Bishop James McHugh (fourth from the left) informed the audience that his mother was Italian.

This 1999 photograph shows the audience listening to speakers at Nassau Community College. The occasion was a presentation in honor of the publication of *The Italian American Experience: An Encyclopedia*. The Center for Italian American Studies at Nassau Community College facilitated the project.

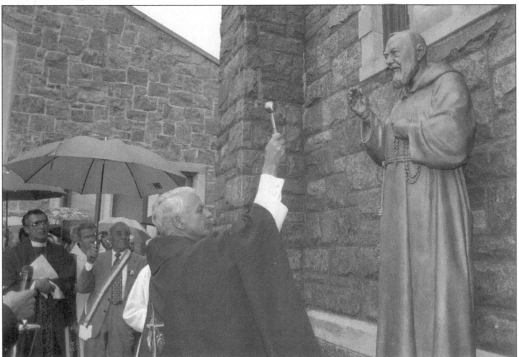

Recently beatified Padre Pio holds special meaning to Long Island Italian Americans. Many of them assembled to observe the blessing of his statue in Glen Cove in 1994.

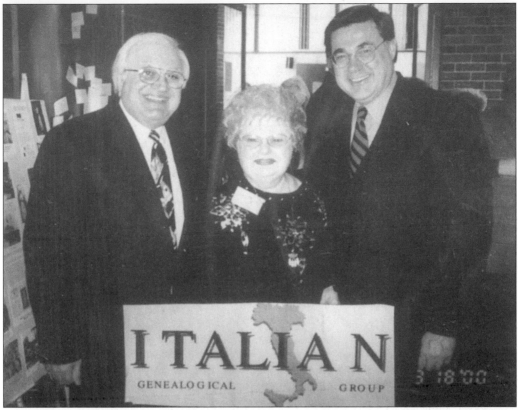

The Italian Genealogical Group of Long Island is an energetic organization with a sizeable membership interested in examining their Italian roots. Pictured at a March 2000 meeting, from left to right, are Peter Zuzolo, former state president of the Order of the Sons of Italy; Barbara Florio of the society; and Ed Romaine, Suffolk County clerk.

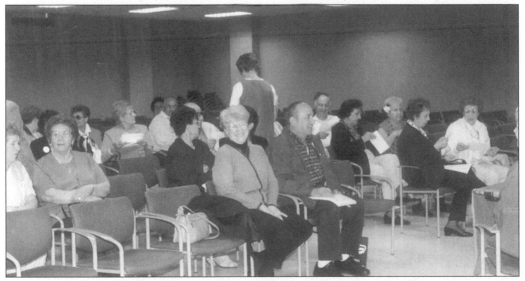

For years, the Italian Cultural Society of South Farmingdale has been holding regular meetings dealing with Italian heritage. Here, the audience prepares for meeting in May 2000.

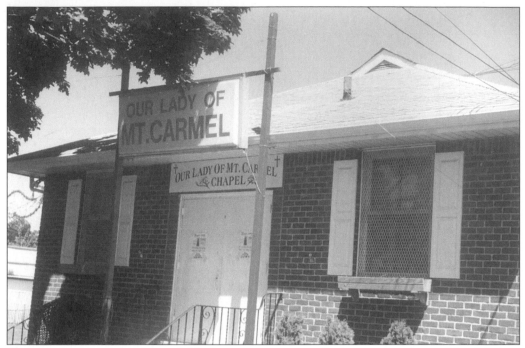

Feasts in honor of the Blessed Mother occupy a special place among Long Island Italian Americans. For decades, the clubhouse of Our Lady of Mount Carmel in Franklin Square has been the site for the annual July celebration.

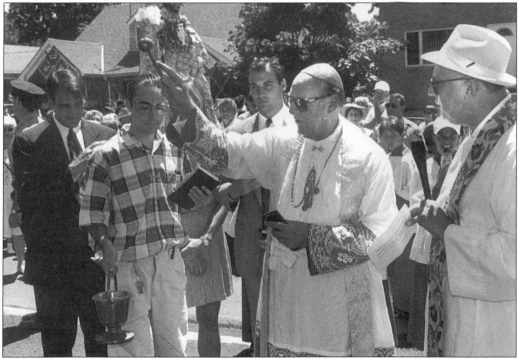

Representing the Vatican, Archbishop Domenico De Luca, blesses new parking lot at St. Rocco's Glen Cove. Directly behind him to the left is the mayor of Glen Cove, Thomas Suozzi.